RED BANK

NEW JERSEY

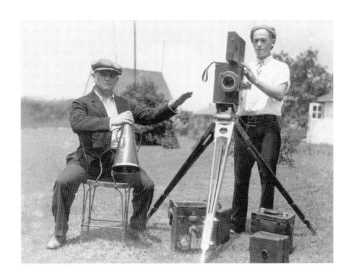

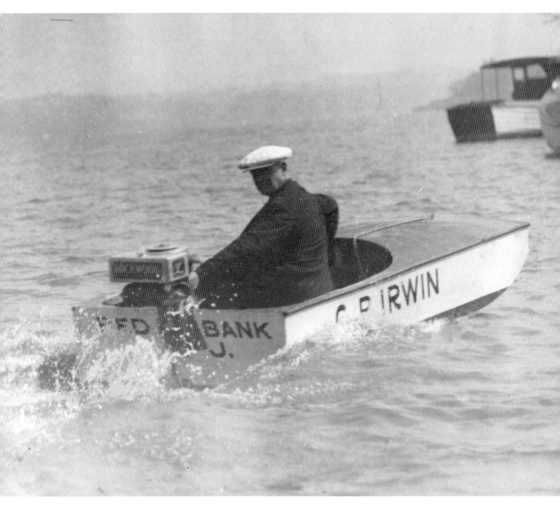

Capt. Charles Irwin
Capt. Charles P. Irwin, the son of Capt. Edward Irwin, motors along in the *C.P. Irwin* during a speed launch race at a carnival on the Navesink River in 1906. (Courtesy of the Irwin family.)

Page 1: The Dorn Dynasty
The film and still photography skills of Daniel DuBouchet Dorn (left) and son Daniel Whitfield Dorn Sr. helped to make the past present for readers of this book. (Courtesy of Dorn's Classic Images.)

LEGENDARY LOCALS

OF

RED BANK
NEW JERSEY

EILEEN MOON

LEGENDARY
LOCALS

Legendary Locals is an imprint of Arcadia Publishing
Charleston, South Carolina

Printed in the United States of America

Library of Congress Control Number: 2013933048

For all general information, please contact Arcadia Publishing:
Telephone 843-853-2070
Fax 843-853-0044
E-mail sales@arcadiapublishing.com
For customer service and orders:
Toll-Free 1-888-313-2665

Visit us on the Internet at www.arcadiapublishing.com

Dedication
To all those, past and present, known and unknown, whose stories travel the river of Red Bank history

On the Front Cover: Clockwise from top left:
Daniel DuBouchet Dorn and Daniel Whitfield Dorn Sr., legendary photographers (Courtesy of Dorn's Classic Images, see page 124), Rock-and-roll icon and local philanthropist Jon Bon Jovi (Courtesy of Mark Weiss; see page 96), Capt. Edward Irwin (Courtesy of Dorn's Classic Images; see page 12), legendary E Street Band brothers Clarence Clemons and Bruce Springsteen (Courtesy of Mark Weiss; see page 119), Tim McLoone, founder of Holiday Express (Author's collection; see page 102), Dr. James W. Parker Jr., Red Bank physician and community role model (Courtesy of Dorn's Classic Images; see page 67), the Reussille twins modeling gowns at Mustillo's (Courtesy of Dorn's Classic Images; see page 48), Sigmund Eisner, manufacturing mogul and philanthropist (Courtesy of Red Bank Public Library; see page 41), Evelyn Leavens, artist and art teacher (Courtesy of Dorn's Classic Images; see page 76).

On the Back Cover: From left to right:
William "The Count" Basie (Courtesy of Dorn's Classic Images; see page 70), the Kathryn Barnett Dancers of Holiday Express (Courtesy of the Kathryn Barnett Dancers, see page 102).

CONTENTS

FOREWORD

Dear Readers:

It gives me great pleasure to invite you to explore these pages of legendary locals, authored so magnificently by Eileen Moon. The borough of Red Bank has created an environment and atmosphere for the development of many diverse cultures and traditions over the decades, which are depicted in this book. You will see the lives and experiences of a myriad of individuals and families and partnerships that have made Red Bank a center for diversity and culture in New Jersey and the region.

Individuals who have immigrated to Red Bank and those fortunate enough to be born on its soil have been inspired by generations of ancestors, and they have, in turn, infused our local culture with a proud history and new ideas. It is that blending of acceptance, diversity, and creativity that has made Red Bank the center of the boundless energy that continues to drive forward our constant march into new ages.

I welcome the reader to appreciate the contributions of so many individuals and families reflected in this book and to consider joining those of us who are happy to call ourselves residents of Red Bank and to share in our future together.

Very truly yours,
Pasquale Menna
Mayor of the Borough of Red Bank

The Four Corners
The Allen House stands at the four corners in Shrewsbury beside what became Sycamore Avenue, once a well-traveled Indian trail. Colonists granted land under the Monmouth Patent began to arrive here in the mid-1600s. There was no "Red Bank" then, and there would not be—at least officially—for more than 150 years. (Courtesy of Lloyd Garrison.)

ACKNOWLEDGMENTS

Creating a book like this does not just take a village, as that old proverb goes; it takes a community. There are many people who contributed to this Legendary Locals project, and I want to extend my personal thanks to each of them for sharing their lives and their talents with the readers of this book.

I hope that long after we are all history, this book survives, to shed a little light on our time for the folks who follow in our footsteps here in Red Bank.

In the course of this project, it rapidly became obvious that there are many more legendary locals than one small book has space to celebrate.

I hope that readers will enjoy learning some of the amazing stories behind familiar faces and familiar places.

And I hope they are inspired to learn more about the artists and adventurers and makers and doers who breathed life into the town of Red Bank over the centuries.

My immense thanks go to George and Kathy Dorn Severini for their invaluable help and more invaluable friendship during the making of this book and to the writers, historians, artists, and photographers who contributed their knowledge, skills, and talents to bringing these legendary locals to life.

And I would like to extend a particular thank-you to the Eisner family, who, in memory of their parents, Sigmund and Bertha, donated their family home to Red Bank for use as a public library. Generations of families, including my own, have been enriched by that gift. Many more stories are waiting to be discovered in the archives of Red Bank Library, and I thank local history librarian Elizabeth McDermott for her patient assistance in hunting down the stories in this book.

I would also like to thank my editor, Erin Vosgien at Arcadia Publishing, for her support and assistance as this book grew into a manuscript.

My final thank-you goes to my family, whose help, encouragement, and practical support made this book possible.

INTRODUCTION

They knew the woods and rivers, the rolling hills and grassy meadows; they heard the whistle of bobwhites in the woods and the rustle of leaves in the wind. They—the Native Americans—were the very first legendary locals. For the Indians and those who came after them, the area now called Red Bank was a natural paradise. Its waters were rich with oysters and clams; its bushes were heavy with berries in the spring; its forests were alive with game.

They were called the Neversink, or Navesink Indians, an English language approximation of the name they called themselves. These Native Americans knew their way through the wilderness, traveling the river in dugout canoes. They were members of the Lenni Lenape Nation, a name variously translated as "man," "common people," or the "original people."

Their language was called Unami, which identified those who spoke the dialect as the "people who live down river." The river itself, officially known as the North Shrewsbury, is more commonly called the Navesink—one of the few reminders of the original people who traveled its waters some 6,000 years before human beings from other lands set foot on the soil of the New World.

In the past, historians described these natives as migratory, traveling north in the winter to hunt and south in the summer to fish, but that view is no longer considered accurate. Though they may have camped seasonally to fish, pick berries, or hunt, like the newcomers who were to follow them, they considered this land their home.

According to the Lenni Lenape creation myth, North America was formed when a giant tortoise rose from the sea, and a tree grew up on its back and became a man. A second shoot took root, becoming a woman, and they lived together on the earth. But even as they continued their lives of hunting, gathering, and fishing, change was inexorably on its way.

Giovanni da Verrazzano, an Italian explorer sailing for the king of France, mapped the Atlantic coast in 1524, sailing into what would become known as New York Harbor. According to the book, *New Jersey: A History of the Garden State*, edited by Maxine N. Lurie and Richard Veit, Verrazzano described the Indians he encountered as "mostly loving." The Verrazzano–Narrows Bridge in New York City was named in tribute to his explorations of this New World.

In 1609, English explorer Henry Hudson and his crew, sailing for the Dutch, came ashore on nearby Sandy Hook from the ship *Half Moon*. This time, the reception was a much cooler. The natives attacked, killing one member of Hudson's crew. But eventually, a trading relationship began between the Native Americans and Europeans, with the Indians trading for items that included tools, cooking implements, knives, fishhooks, and alcohol.

With the newcomers came diseases like measles and smallpox that devastated native populations. And as settlers moved onto lands once the domain of Native Americans, conflicts, sometimes bloody, followed. At various times, both the Dutch and the English claimed the territory now known as New Jersey. Ultimately, the English prevailed, and in the mid-1600s, the sachem of the Navesink, known as Popamora, signed an agreement to sell the land on the eight-mile-long peninsula that includes Red Bank to the English.

With the issuance of the Monmouth Patent in 1665 by Royal Governor Richard Nicholls, the area opened to settlers, who could claim 120 acres per person in this soon-to-be-tamed wilderness. This region was divided into two segments: Shrewsbury and Middletown. At one time, the Red Bank riverfront was known as Shrewsbury Dock. Farms were being established throughout the area, and some were within the region that would eventually become Red Bank.

One of these is the White Homestead, which was built about 1688. The White family members were

Quakers, but despite their faith-based pacifism, their home became the scene of some Revolutionary War skirmishes. The White Homestead, still a private residence, is the oldest existing home in town.

Within a few decades of the signing of the Monmouth Patent, there were few traces of the Native American presence in the region. Many had gone elsewhere, some settling on a reservation called Brotherton, which was officially established by the government for Native American settlement, and others traveling out to Wisconsin to join members of their tribe seeking refuge farther West. Meanwhile, newcomers from Europe and other parts of the New World continued to find their way to this region.

And with these settlers from more urban areas came the need for every kind of service. Some of the newcomers practiced the trades they had mastered in the Old World; others found entirely fresh ways to earn their keep in this new country.

In 1667, the Parker family established a homestead in a portion of Shrewsbury Township that eventually was incorporated as Little Silver. They were the first of seven generations of Parkers to make their home there. They named Little Silver as a reference to their ancestral home in Portsmouth, England. In the mid-1800s, a Parker daughter married into the Sickles family creating a farming dynasty that continues today with the enduring presence of Sickles Market, a former farm stand that is now a world-class gourmet emporium.

In her book *Up and Down the River*, published in 1980, author June Methot notes that the first recorded mention of the name "Red Bank" occurred in a log kept by the captain of the sloop *Portland* in 1734: "A journal by God's Permission from Red Bank to New York distant 12 Leagues in ye sloop *Portland* and back Again." That round-trip journey to New York took 13 days.

Another account from 1736 details Thomas Morford's sale of "over three acres on the west side of the highway that goes to the red bank" to Joseph French.

But by the early 1800s, Red Bank's identity as a village distinct from Shrewsbury Town was growing along with its population. Red Bank first became a town separate from Shrewsbury Township on March 17, 1870. An effort to rename it as Shrewsbury City failed in 1879, and Red Bank reclaimed its two-word name. Twenty-nine years later, on March 10, 1908, the New Jersey legislature officially incorporated the town as Red Bank.

Like the ancient inhabitants who preceded them, the newcomers who settled here were drawn to the river, which made it possible to live well, dream big, and travel far. Their names survive on street signs and in the inscriptions at the tops of some buildings. Their names survive in the names of many of our neighbors, like Irwin, Sickles, Doremus, and many more.

Some of the early Red Bank residents came to ply the rich waters of the Navesink River, harvesting its bounties to sell in the markets of New York City or transporting coal and iron to the lumberyards and foundries.

Farmers from many miles around carried their produce to Red Bank for sale in town and transport to city markets. Bushels of oysters, baskets of clams, eels, flounder, crabs, porgies, and perch were among the plentiful bounties of the river. The famous Shrewsbury oysters were in particular demand. In 1881, oystermen were shipping some 200 barrels a day into New York City during oyster season.

An account from 1878, published in Methot's book, recalls the halcyon days of oystering in Red Bank: "Old men tell of having seen in the remote past as many as 500 men, women and children wading in the river in search of its treasure. The first of September, which marked the lifting of the law with reference to oyster catching, witnessed long lines of wagons, coming sometimes as far away as from twenty miles in the interior, each having many occupants, who, equipped with tubs, would engage in this lucrative business."

One of the most famous riverboat captains was Edward Irwin. Born in Middletown about 1832, Irwin worked on the river from the age of 10, ferrying loads of sand to the foundries in Elizabeth and delivering produce to the markets of New York. He died on the river, too, aboard the schooner *Jorden Woolley*. Captain Irwin's love of the river has carried through four generations. His great-grandson Channing Irwin still operates the family marina and boat works at the edge of Marine Park.

Legend has it that the first business to open its doors in Red Bank was a tavern that served the

farmers and river men; Barnes Smock operated it. The tavern was built on a hillside overlooking the river on a lane that would eventually become known as Wharf Avenue. Soon, there was a store across the street. Around 1804, the Union Hotel either replaced or was added onto the tavern, providing early travelers with a night of sleep off the water and out of their wagons. Barber & Howe's *Historical Collections of the State of New Jersey* describes what the town looked like in 1844:

> The village of Red Bank is pleasantly situated on the Navesink River. It is, with exception of Keyport, the most rapidly increasing village in the state. In 1830, it contained but two houses, viz: the old tavern-house, on the river bank, and the small dwelling now owned by John Tilton, Esq., about 12 rods w. of the shore. The principle source of its prosperity is trade with New York. Thirteen sloops and schooners sailed from here with vegetables, wood and oysters for that market and a steamboat plies between here and the city. Vessels, week after week, have taken oysters to New York and returned with $600 or $700 for their cargoes. Red Bank contains 7 mercantile stores, 1 hat manufactory, 2 wheelwrights, 2 lumber-yards, 2 blacksmiths, 2 shoe stores, 2 ladies' fancy stores, 4 tailors, 1 bakery, 2 tinners, 1 lime-kiln, 1 sash and blind factory, a Forum for public meetings, an Episcopal chapel and 60 dwellings.

According to local lore, the original tavern remained part of the hotel for nearly two centuries, enduring into the 1990s as the Olde Union House restaurant. As the look of the shoreline altered and the population of this little settlement expanded, life on the river changed, too.

By the 1850s, the river was a busy highway, populated by packets and schooners. Bridges had not yet been built between the north and south banks of the Navesink River. The only alternative to a somewhat risky and cumbersome horse-and-wagon transit across the shallowest part of the river was by sail.

Before the advent of the steamboat era starting in the 1830s, "the river was white with sails every day and every Red Bank boy could name every boat as soon as it stuck its nose around Pintard Point," reads a 1900 newspaper account from the *Red Bank Register*. The arrival of steamboats and trains increased the movement of people and goods between hamlets and city.

The first newspaper published in the area was the *Red Bank Standard*, founded by Henry Morford in 1840. Morford, a Middletown native, served as editor of the paper for six years before passing on the editorship to Charles Conrow with the stipulation that Morford retained the right to publish his poems and other literary creations in the *Standard* at will. Morford's ambition was to become a successful author, and he ultimately accomplished that, publishing 17 volumes of novels, stories, and poems over a literary career that included writing for the *New Yorker* and traveling throughout Europe. Many of the poems that appeared in one of his most famous works, *Rhymes of an Editor*, published in 1873, first appeared in the *Standard*.

But the paper that endured the longest and preserved in the most detail the history of Red Bank was the *Red Bank Register*, which chronicled goings-on in the town of Red Bank for more than 100 years. John Cook was the owner and publisher of the *Register*.

In celebrating the history of this small town on the river in 1900, the *Register* noted proudly that the town now had a population of 8,000 and was growing faster than any town in Monmouth County:

> Ten churches, 5 public schools including a high school, a parochial school, several private schools, two weekly newspapers, a board of commerce, building and loan association, a steamboat line to New York, a public library, a sewer system, the purest water to be obtained because it is drawn from artesian wells, five firehouses, two national banks, young men's Christian (sic) association, gas and electric light plants, two miles of river frontage, two trolley lines, free mail delivery, postal savings bank, forty-four lodges and societies, farmers' grange and farmers' club, three boat clubs, two iceboat clubs, cavalry troop and many other things that go to make up a splendid town to live in.

And as decade followed decade, the town endured, its destiny altering with the times and aspirations of those who claimed the town as their own.

CHAPTER ONE

At Home on the River

For a century and more, the Navesink River was alive with sails; the journey of each vessel was dependent on tide, wind, and season. The river was the highway that brought produce, oysters, coal, iron, sand, and lumber to the city. It was the commuter hub that brought newcomers to the region and brought in items to stock the shelves with material goods in the gradually civilizing wilderness.

The first steamboat to appear on the Shrewsbury River sailed between New York City and Eatontown Dock (now Oceanport). The boat ran only a few months in the summer of 1819, making three round-trips a week.

Seeking a more efficient way to get his products to market, James P. Allaire, owner of the Howell Ironworks, commissioned the first steamboat, the *David Brown*, to travel from Red Bank to New York in 1832.

Steamboat traffic increased on the Navesink River through the mid-1800s. Many of the commercial boats also carried passengers, making it possible for people to come and go between city and settlement in relative ease. During the Civil War, the US government commissioned several local boats for the war effort.

With the coming of the railroad, traffic on the river eased; although, steamboats continued to run well into the 1900s. As the town prospered, there was time to enjoy picnics by the water, to embrace the "manly art" of rowing, or to try out the popular sport of ice-skating.

In 1879, a group of local gentleman established the Monmouth Boat Club (MBC). The names of the founders are familiar ones in the history of the town. According to the documentation submitted by the club in its application for inclusion in the National Register of Historic Places in 1994, "the ten founders were Dr. Field, a respected physician and surgeon; Enoch Cowart, a bank clerk; Thomas H. Applegate, a hardware merchant; Archibald Antonides, a carpenter; Ephraim E. Ovens (occupation unknown); William Pintard, a lawyer (and subsequently the first president of MBC); George V. Sneden, an employee of the railroad; William N. Worthley, a coal merchant; William L. Sneden, a civil engineer and Dr. Horace B. VanDorn, a dentist. All were residents of the town." The stated purpose of the club was "to promote physical culture and more especially the manly art and exercise of rowing."

Another historic river club occupies a smaller building on the property of the MBC—the North Shrewsbury Iceboat and Yacht Club. Three generations of the Irwin family sailed Class A iceboats on the river starting in the early 1900s and continuing well past the time most people retire to their rocking chairs. Daniel V. Asay, who was still iceboating in his late sixties in 1914, proudly claimed to be the oldest iceboater on the river. He was competing in the national championships at the time.

Capt. Edward Irwin

Among the more colorful characters to make his life on the river in Red Bank was Capt. Edward Irwin. Born in 1832, Captain Irwin boasted that he ran away from home at the age of 10 to make his living on the water. The son of William Irwin, he was born in Middletown. The family's roots were Scotch-Irish, but the Irwins had been here well before the American Revolution—William Irwin's father was a veteran of the colonial army.

After earning his wings on the water, Edward ran a schooner from Red Bank to New York, carrying bricks, coal, and produce to the Fulton Street market. He served as assistant pilot of the steamboat *Jesse Hoyt* on its New York-to-Sandy Hook run and then captained a series of boats, including the *Hiram B. Edwards*, the *Lawrence Price*, the *Belle*, and the *Jorden Woolley*.

He married a Fair Haven girl, Johanna Springsteen, about 1850, and the newlyweds settled in Red Bank, where they lived until their deaths.

Irwin left local waters for a few years to join the Union navy during the Civil War. He served 18 months with the 1st New York Volunteer Engineers, Company K.

In the late 1890s, he and son Capt. Charles P. Irwin had a heated confrontation over the elder Irwin's reluctance to leave the water. Taking matters into his own hands, Capt. Charles Irwin went down to the family boatyard on Wharf Avenue with an ax and cut the dock lines on his father's boat, the *Hiram B. Edwards*.

Undeterred, Captain Edward climbed aboard the schooner *Jorden Woolley*, which was owned by his friend Thomas Brown, and continued his career on the water.

The elder Irwin died of natural causes on the *Jorden Woolley* in 1900. He had been heating the kettle for bathwater when death came to him "through a stroke of apoplexy," the *Red Bank Register* reported. He was 67. (Courtesy of Monmouth Boat Club.)

The Irwin Dynasty
Here, Capt. Charles Irwin is pictured with his three sons, Charles (far left), born in 1908; Edward (second from left), born in 1906; and Joseph (far right), born in 1904. Charles and Edward served as naval officers during World War II. Joseph was elected councilman and mayor in Red Bank, served in the New Jersey assembly, and was director of the Monmouth County Board of Freeholders for 36 years. (Courtesy of the Irwin family.)

Irwin's Marine Works
Capt. Charles Irwin launched his boat-building business from a shack he rented from John W. Stout, owner of a nearby canning factory. He paid his rent with soft-shell crabs. (Courtesy of Monmouth Boat Club.)

13

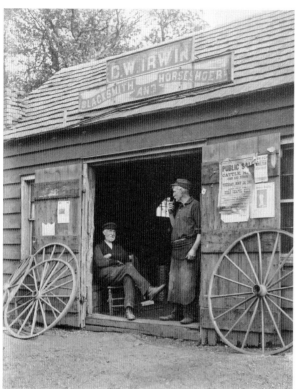

The Other Irwins

Not all the Irwins were on the water. Capt. Charles Irwin's uncle Daniel W. Irwin (Captain Edward's brother) operated a blacksmithing and horseshoeing business in the Chapel Hill section of Middletown for more than 50 years. Edward, Daniel, and two other Irwin brothers, Thomas and Harrison, all served in the Civil War. (Courtesy of Dorn's Classic Images.)

Racing on Ice

Captain Charlie's iceboat, *Georgie II*, was considered by locals to be among the fastest in the world. A member of the North Shrewsbury Iceboat and Yacht Club (NSIYC), the captain earned his share of championships on the ice. He had a particular rivalry with fellow NSIYC member Charley Burd. (Courtesy of Dorn's Classic Images.)

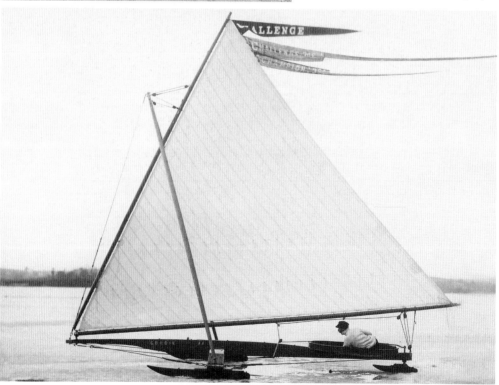

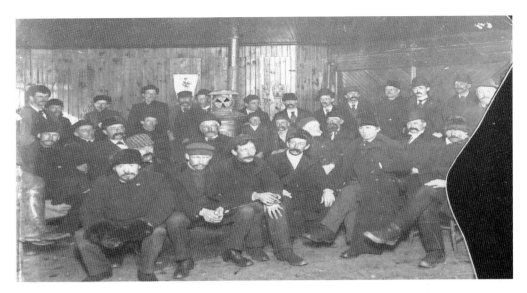

Rivals on the River
In this c. 1895 photograph of NSIYC members, Charley Burd is second from left, and Capt. Charles Irwin is third from left in the front row. Burd and Irwin were rivals on the ice and on the water for more than 50 years. (Courtesy of Monmouth Boat Club.)

THE FAST AND COMMODIOUS STEAM LAUNCH

"LEON ABBETT"

FOR CHARTER,

BY WEEK, DAY OR TRIP.

For particulars and terms apply to,

CAPT. CHARLES P. IRWIN,

Red Bank, New Jersey.

Photo of C. S. DAY, 2 West 14th St., New York.

Charter for Hire
Here, Capt. Charles P. Irwin advertised his charter business on the "commodious steam launch," the *Leon Abbett*. Leon Abbett was a Democratic politician who twice served as governor, having been elected in 1883 and 1889. He was also a staunch advocate for riparian rights, which may be why Irwin named his launch in his honor. (Courtesy of Monmouth Boat Club.)

"The Manly Art of Rowing"
Monmouth Boat Club's 1881 champion rowers are Dr. Edwin Field, center, a Red Bank physician who first proposed the establishment of a boating club on the Navesink; George V. Sneden, left, an engineer for the New York & Long Branch Railroad; and bank clerk Enoch L. Cowart. The founding members of the club were young businessmen involved in many community pursuits. (Courtesy of Monmouth Boat Club.)

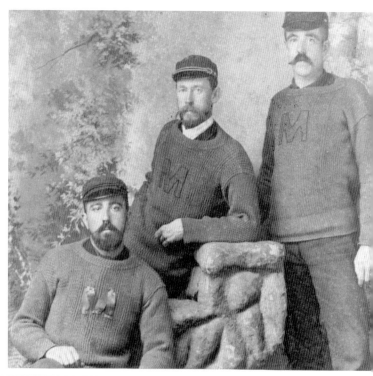

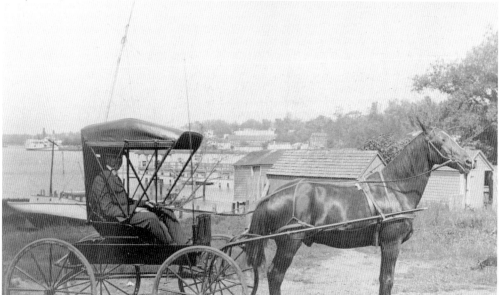

Man about Town
In addition to the establishment of the Monmouth Boat Club, Dr. Edwin Field was also involved in starting the North Shrewsbury Iceboat and Yacht Club, the Shrewsbury Canoeing Club, and the Red Bank Elks. A Middletown native, Field graduated from the College of Physicians and Surgeons in New York City. He began practicing medicine in Red Bank in 1876. He was also a staff physician at Monmouth Memorial Hospital. (Courtesy of Monmouth Boat Club.)

Monmouth Boat Club Expands

In 1884, members expanded the boathouse they had built in 1880. Above, Dr. Field is standing to the right of the white-bearded Commodore Joseph T. Burrowes Sr., a lumber merchant. The man holding a hammer is believed to be Archibald Antonides, a carpenter by profession and a founding member of the club. (Courtesy of Monmouth Boat Club.)

1883, M.B.C. acquired a new neighbor right where the tennis courts are now--
In W. Stout's ketchup factory. This scene was made inside the factory during the sy season. They also canned asparagus in June and peaches in the fall. The capa-y of this busy establishment was 500,000 cans per season and they used only the st of cans made of 'iron sheets coated with tin', never coating them with lead which uld lead to poisoning. They also manufactured the cans during the off-season.

The Ketchup Factory

By the late 1800s, Red Bank's waterfront was a busy place. John W. Stout established a canning factory where the tennis courts are today. The factory canned tomatoes, peaches, and other fruits and vegetables and spent the winter making cans for the next year's produce. Stout had another factory in Bridgeton. The site was previously a storehouse for farmers sending produce off to market and, later, became the Lyceum Theater. (Courtesy of Monmouth Boat Club.)

No Business like Show Business

Professional theater people established their own boat club on the river in Fair Haven called the Players Club. Their annual show at Fred Frick's Lyceum Theater in Red Bank was always a sellout. Combining business with the pleasure of being out of the city in the summer, Broadway directors used the Lyceum for professional tryouts for soon-to-be Broadway shows. (Courtesy of Monmouth Boat Club.)

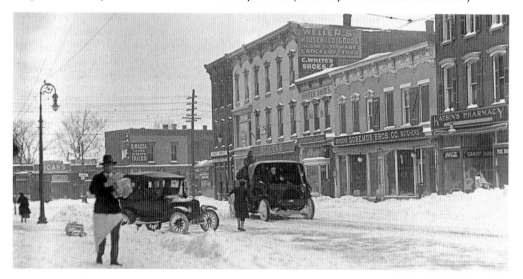

Generations in Red Bank

The Doremus family's deep roots in Red Bank date to the 19th century when two brothers, Albert and Newton, opened a market on Broad Street. Today, the Doremus family's commitment to community service stretches back over five generations. Thomas "TD" Doremus, 29, whose parents, Thomas and Debbie, are the owners of Dean's Flowers, is a borough police officer and former chief of the borough fire department. (Courtesy of Dorn's Classic Images.)

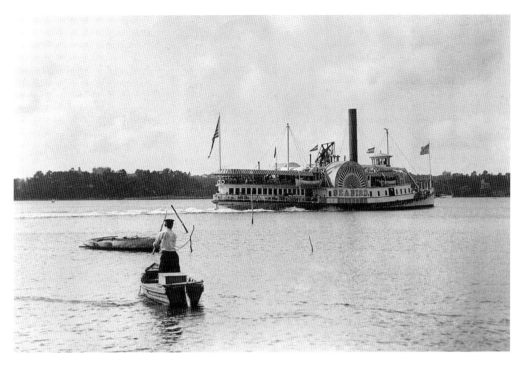

Sailing the Bird
Launched by the Merchants Steamboat Company of New York in 1866, the *Sea Bird* was captained by Henry B. Parker, whose ancestral roots in the region stretched back to the 1600s. He eventually acquired a quarter ownership in the company, as did his pilot, F. Asbury Little. The *Sea Bird* was the largest steamboat on the Navesink River and the most luxurious. (Courtesy of Monmouth Boat Club.)

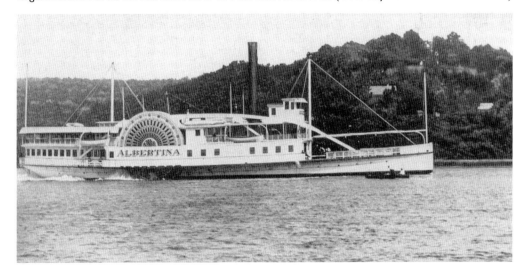

The Lovely *Albertina*
Capt. James S. Throckmorton was captain of the *Albertina* and eventually owner and president of the Merchants Steamboat Company. When he retired in 1889, his son Charles became captain. Throckmorton was also credited by the *Red Bank Register*, which began publishing in 1877, with being its first subscriber. Throckmorton died in 1910 at the age of 81. (Courtesy of Monmouth Boat Club.)

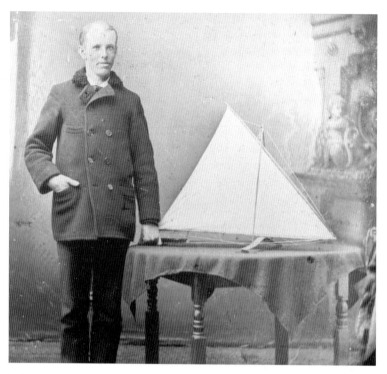

Racing Uncle Bob
Thomas S. Hubbard stands with a model of his champion iceboat, *Uncle Bob*, in 1885. Hubbard was a founding member of the Monmouth County Wheelmen, a group of "gentlemen bicycle riders," organized in 1883. Dr. Edwin Field was also a founding member. Hubbard served as commodore of the Monmouth Boat Club from 1913 to 1931. (Courtesy of Monmouth Boat Club.)

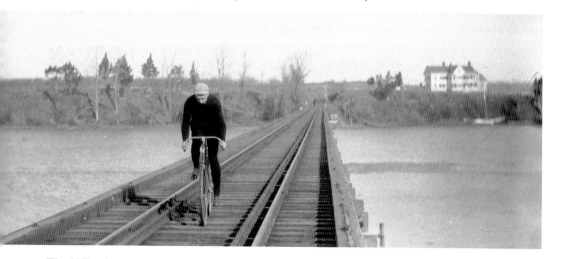

The Wheelmen
An unidentified member of the Monmouth County Wheelmen crosses the old railroad bridge between Middletown and Red Bank, sometime in the 1880s or 1890s. The Monmouth County Wheelmen became a large organization that competed with other bicycle racing teams in the American League. (Courtesy of Monmouth Boat Club.)

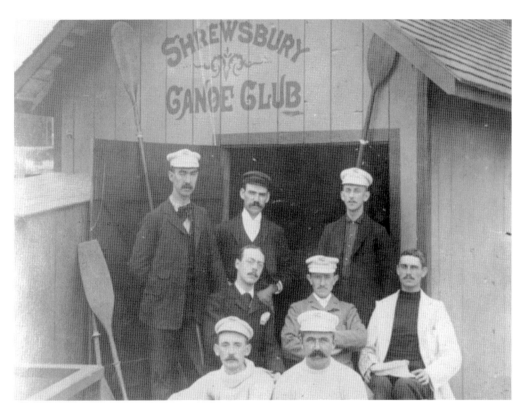

The Canoe Club

Canoeing became popular in the 1880s, and once again, Dr. Field helped out by lending his boathouse for use as club headquarters. Members of the club included, from left to right, (first row) Riviere Sneden and Harry Payne; (second row) Fred Frick, Joseph Applegate, and Will Allaire; (third row) John Mount and two identified men. (Courtesy of Monmouth Boat Club.)

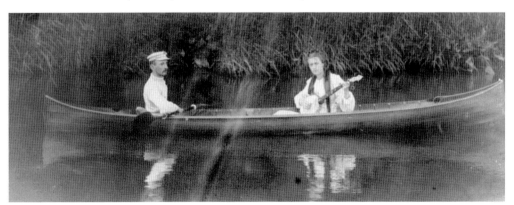

Still Life with Banjo

Riviere Sneden and Mamie Lawson enjoy a leisurely day of canoeing the Navesink River in 1887. A group of enthusiasts that included Dr. Edwin Field established the canoeing club to enjoy outings on the river. Riviere Sneden, described in the *New York Times* as a "prominent young businessman and officer of the New Jersey State Democratic Society," married Anna Grant Hubbard in 1894. (Courtesy of Monmouth Boat Club.)

The Catboat *Olivia*
Here is the crew of the catboat *Olivia* in 1878. Standing from left to right are early members of MBC Joe Swannell and Will Worthley. The Worthley family owned a coal yard a few yards from the boat club. Seated are Thomas S. Hubbard (left) and John S. Sutton. (Courtesy of Monmouth Boat Club.)

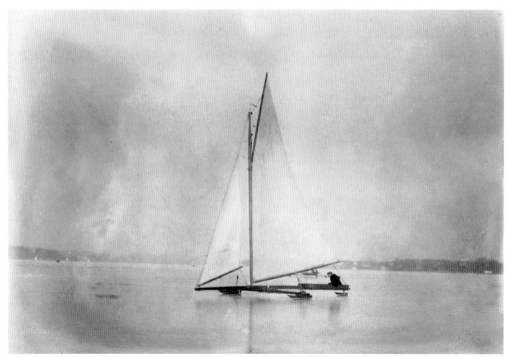

"The Oldest Living Iceboater"
Before his death at the age of 83 in 1930, Daniel V. Asay claimed to be the oldest iceboater in the world. Born in 1847, he moved to Red Bank with his parents, Edward Parker Asay and Hannah Van Note, around 1850. A mason contractor, his avocation was designing and racing iceboats. His champion iceboats included the *Zero* and the *Gull*, pictured. (Courtesy of Library of Congress.)

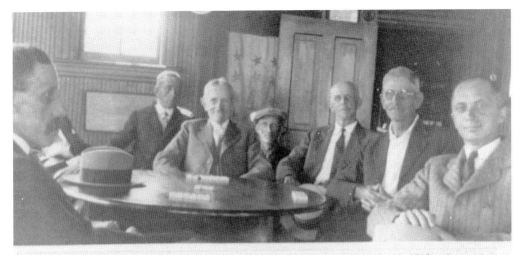

The 'St. Petersburg' gang in action (Dominoes?) This picture was taken in 1928 and except for a change in the color of the paint, this is just the way the third floor looked when we tackled it last fall. L. to R. Jos Raymond, John L. Hubbard, Joe Applegate, Del Fisher, Thomas Hubbard, Elwood Minugh and George Bray.

Fun and Games

Domino games were a popular pastime at MBC, with championship contests taking place on the men-only third floor of the club, long known as "St. Petersburg." In 1930 and 1931, Charles A. Minton and John L. Hubbard won the boat club domino championship with a record of 27 wins and 14 losses in a competition that included eight teams and 42 members. (Courtesy of Monmouth Boat Club.)

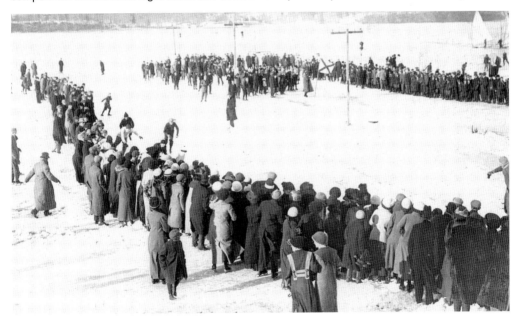

The Winter Carnival

Red Bank entrepreneur Fred Frick initiated the idea for an annual winter carnival. In 1912, utility poles were actually installed in the river so that people could ice skate under electric light after dark. Members of the MBC judged skating races and opened their doors to the public, where the fun continued into the wee hours. (Courtesy of Monmouth Boat Club.)

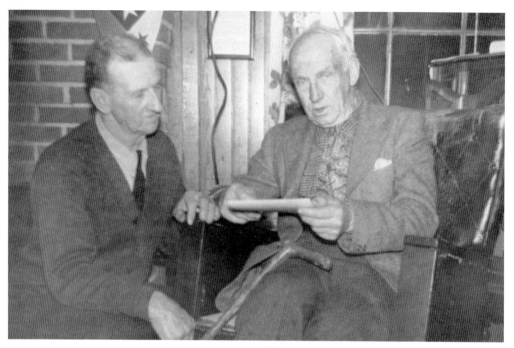

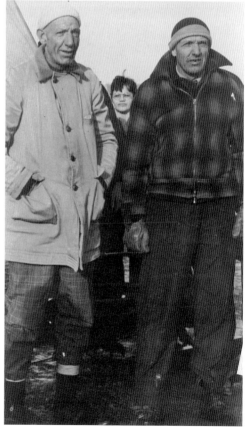

Old-timers
Rube White (left), the son of Capt. Jack White, and Captain Irwin's racing rival Charlie Burd reminisce in the NSIYC sometime in the 1950s. Burd's adventures on the water spanned more than a half-century, from 1885 to 1950. White was also a champion iceboat skipper. Burd died in 1958, and White died in 1965. (Courtesy of Monmouth Boat Club.)

Brothers on the River
Oscar "Hatchet" Brand (left) and his brother Frank (right) were familiar faces on the Navesink River. Both were old-fashioned river men who earned their living in ways dependent on the water: crewing on steamboats, crabbing, and working in local boatyards. In their youth, they raced famous iceboats owned by the Gillig and Thomas Irving Brown families. According to Monmouth Boat Club history, Oscar became a "gentleman of the river," assisting people with their sailboats and was particularly kind to kids. The two brothers were remembered as opposites—Oscar gentlemanly and soft-spoken and Frank rough-edged and salty. Frank became the Monmouth Boat Club's only live-in steward when he occupied an apartment in the original clubhouse. The two brothers died in the 1960s. (Courtesy of Monmouth Boat Club.)

Unfounded Suspicion

Like the Irwins, Hans Wulf (pictured with his daughter, Elizabeth Clare) operated a boat works on the water in Red Bank, but there was no love lost between Wulf and Charles Irwin. The owner of the Red Bank Marine Works, Hans Wulf had been a U-boat captain during World War I, and when the United States went to war with Germany in World War II, Wulf's loyalty to his new country was in question. An accomplished boatbuilder and world-traveled mariner, Wulf had decided to break his ties with his home country after the Nazis came to power. Although he had built a successful business, achieved renown as the designer of a popular skiff called the *Sea Wulf*, and had already built boats for the US Army, he was not yet a citizen. As his daughter Elizabeth Clare Prophet recounted in her autobiography, *Preparation for My Mission*, two FBI agents knocked on the family's door at 43 South Street on the evening of March 3, 1942. Hans Wulf was placed under arrest as an enemy alien and confined at Ellis Island. Neighbors and business associates testified on his behalf, swearing that he was an upright citizen and that he had no ties with Nazi Germany. He was released on parole on April 17, 1942, after six weeks in custody. He always suspected that his business rival Charles Irwin had been responsible for his arrest, but it appeared instead that Wulf had simply been among those of German origin who were rounded up as enemy aliens in the early days of the war. Whenever her father would speak of the experience, Prophet recalled in her book, he would tell her, "Betty Clare, I don't want you to forget that the people who gave me my freedom by coming forward to witness on my behalf were Jews, Rosie Beckenstein, my secretary; Bill Beckenstein, her brother, the pharmacist; and Murray Schwartz, the attorney. Even though I was a German and accused of being a Nazi, which, as you know, I never was, they were willing to stand up for me." (Courtesy of Erin Prophet.)

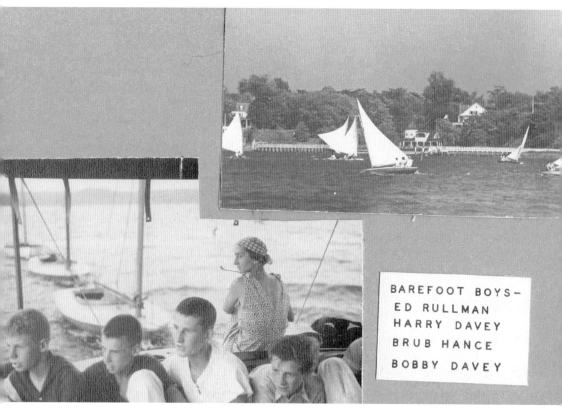

BAREFOOT BOYS—
ED RULLMAN
HARRY DAVEY
BRUB HANCE
BOBBY DAVEY

The Barefoot Sailors

About 1933, a group of young teens from the Monmouth Boat Club started an amateur sailing organization called the Barefoot Sailors, using Dr. Edwin's Field's boathouse as headquarters of their Barefoot Yacht Club. The 29 original members, which included one female, Barbara Sayre Bull, grew up together on the water and most graduated from high school in 1938 and 1939. World War II was soon to end their carefree days on the Navesink River. Pictured above are four of the Barefoot Sailors: from left to right, Ed Rullman, Harry Davey, Brub Hance, and Bobby Davey. The young woman is not identified. (Courtesy of Monmouth Boat Club.)

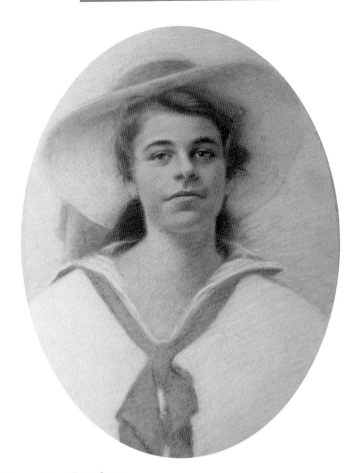

Margaret Rullman Goes Barefoot

At the start of World War II, many of the young sailors of Monmouth Boat Club were going off to war. Monmouth Boat Club Women's Auxiliary member Margaret Rullman, the wife of Dr. Walter Rullman, proposed that the auxiliary work on a newsletter for distribution to the young people who were in uniform. The Rullmans' son Edwards F. Rullman was among them.

Rullman, Katherine Lippincott, and Louise Sayre decided to adopt the name Barefoot Sailors for their bulletin. For five years, they produced the newsletter at their own expense with the help of Lillian Reamer, who did the mimeographing. By the end of the war in 1945, their mailing list had grown to 150 people.

In addition to keeping the young servicemen and women up to date on the goings-on at home, the newsletter also let them know a little of what their friends were doing by passing on tidbits from letters club members sent back home.

While they tried to keep the newsletter light, on two occasions, the women had the sad duty to report to the Barefoot Sailors that two of their friends would not be coming home. Former Barefooters Frank Distelhurst and pilot officer Stuart Rogers Jr. of the Royal Canadian Air Force were killed in the war.

"Stew was the first member of the B.F.Y.C. to make the supreme sacrifice," the bulletin noted in 1943. "He was killed February 7, and was buried with full military honors at Cornwell, England. He received more than one citation for bravery."

During the five years of World War II, 68 members of Monmouth Boat Club served their country. An unidentified artist created this c. 1910 pastel-on-paper portrait of Margaret Rullman. It was a gift from Mr. and Mrs. Edwards Rullman to the Monmouth County Historical Association in 2004. (Courtesy of Laura Poll, the Monmouth County Historical Association.)

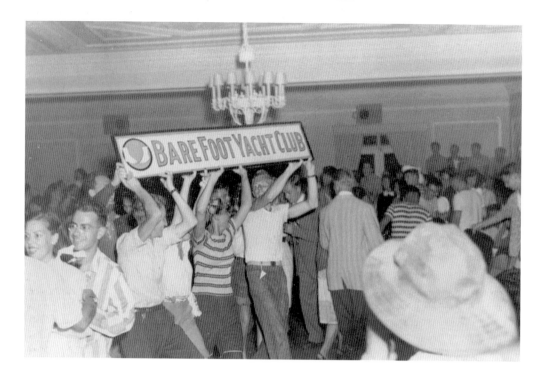

A Joyful Homecoming

Members of the Barefoot Sailors reunited following the war at the Monmouth Boat Club's 1947 Shipwreck Ball, gleefully hoisting the sign that used to adorn the old boathouse. The sign disappeared that night, not to return for several years. It was found in a naval reserve station in North Jersey and was returned to the club's trophy room for posterity. (Both, courtesy of Monmouth Boat Club.)

CHAPTER TWO

Enterprise

Since that first tavern opened its doors to serve the farmers and river men on the hill above the Navesink River, Red Bank has been a town driven by its small businesses. It was a natural progression at first. As more settlers arrived in the region, more services were needed, and as farmers, fishermen, carpenters, and wheelwrights grew prosperous, there was more demand for material goods. The first business credited with opening on Broad Street was a general store, operated by Rice Hetzell at the corner of Broad and Front Streets, in 1829. Steamboats followed sailing vessels around 1840. From then on, the town grew rapidly.

By 1850, the railroad had arrived. Running from Port Monmouth through Red Bank, the New Jersey Southern Railroad enhanced Red Bank's reputation as a transportation hub and reduced the town's dependence on the river for rapid connections to the wider world.

Before the Civil War, Alice Ludlow found a market here for well-tailored clothing. Her store endured under the name Clayton and Magee almost to the turn of the 21st century. In the 1880s, Leon De La Reussille sold fine watches from his store just this side of the "lollipop" clock, which still stands on Broad Street.

During the early years of the 20th century, Sigmund Eisner grew an empire from a modest manufacturing business.

Red Bank attracted the attention of no less a figure than lawyer, poet, and journalist William Cullen Bryant, whose most famous poem is "Thanatopsis." Bryant was editor-in-chief and part owner of the *New York Evening Post* from 1828 until his death in 1878. He was also the editor of *Picturesque America*, published by D. Appleton and Company in 1872. Considered the first comprehensive publication celebrating the American landscape, it included an essay titled "The Neversink Highlands" by O.B. Bunce, which described Red Bank as the most important town on the river:

> Red Bank is in every sense a pretty village and what perhaps is better, a thriving one. Without lifting so high as near the mouth of the river, the hills here are very charming, spreading away in flowing, undulating lines and dipping to the water with many a sylvan grace. It is a town built up in the interests that pertain to a great metropolis, being a sort of entrepot for a large agricultural country, the products of which are sent here for transportation to the city . . . its avenues of cottages and villages extend for miles, while whole fleets of vessels are occupied in its commerce.

The wind-powered schooners of yesteryear gave way to the whistle of trains and the hiss of steamboats carrying passengers and products back and forth from the city. By 1910, Red Bank was growing faster than any other town on this side of the river. The 20th century would bring many challenges, but the borough on the banks of the Navesink River would weather them all.

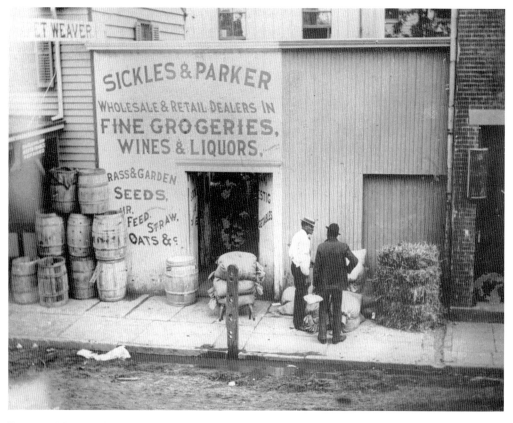

Farm to Market: Sickles and Parker

In the late 1800s, Theodore Sickles started a grocery and liquor business on Broad Street with a member of the Parker family, to whom he was related by marriage.

His partner proved unreliable, and eventually, the business went bankrupt. Sickles and Parker then turned their hands to farming, Sickles on his 28-acre farm and Parker on the neighboring 80-acre property.

Theodore Sickles learned enough to make a go of his farm, but the Parkers were less skilled at agriculture, and eventually, the Sickles family took over farming their property as well. By 1908, Theodore's son Harold was selling the produce they had grown to markets around the region.

Sometime in the 1950s, Harold's son Bob Sickles Sr. started a little farm market on their property where neighbors could pick up their own produce as well as special items the Sickles family brought in from wholesale markets in Red Bank and Newark.

The family lived on the farm, and by the time he was 12, Bob Sickles's own son, also named Bob, was working the family business, and after earning a degree in horticulture at the University of Vermont in 1978, Bob Jr. returned to the farm with some fresh ideas.

It was time for the family to grow the business as they had successfully grown the corn, tomatoes, and peas that had made Sickles a household name in the Red Bank area.

Sickles Market still occupies the property farmed by Theodore Sickles in Red Bank's neighboring town of Little Silver.

Today, Sickles is a world-class market where shoppers can find fresh-picked corn from local fields and exotic products from around the world. Though some consultants urged the Sickles family to focus on their garden and landscape side of the business, the food market has been a major key to their success.

Bob Sickles Jr.'s daughter Tori is the marketing manager. In his 80s, Bob Sickles Sr. is still farming while son Ted manages the garden center. (Courtesy of Dorn's Classic Images.)

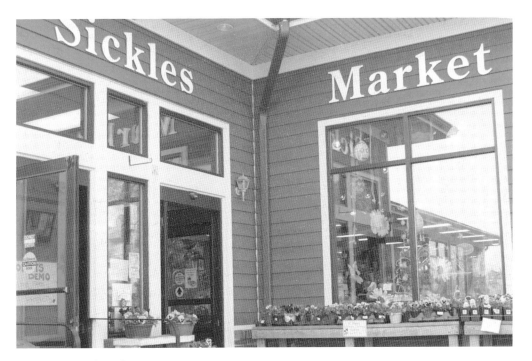

Sickles in the 21st Century
A favorite with local chefs, Sickles Market bustles with happy customers year-round. The store now has sales of over $10 million a year. The Sickles family shares that success by supporting many local charities, including an annual fundraiser for Holiday Express that brings in more than $100,000, all of which goes to that organization, which brings live music, food, gifts, and fun to people in need during the holiday season. (Courtesy of Fortier Photography.)

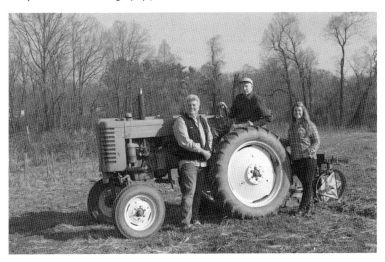

Four Generations
Pictured are third-generation owner Bob Sickles, his father, Robert Sickles, and Bob's daughter Tori Sickles, a fourth-generation owner. They are in Robert Sickles blackberry and raspberry patch. The land has been farmed in some manner since 1665, when it was acquired by the Parker family as a King's Land Grant. Bob Sickles's great-grandfather married a Parker. (Courtesy of Carter Berg Photography)

John S. Applegate.

John Stilwell Applegate Sr.

One thing that was long legendary about Red Bank was the quality of its water, which came from the town's own waterworks. If any one person deserves the credit for that, it is John Stilwell Applegate Sr.

Already a well-known attorney, Applegate was elected to the New Jersey State Senate on the Republican ticket in 1881, serving until 1884. As a state senator, he sponsored a bill allowing small towns like Red Bank to construct and maintain their own water utilities. After the bill became law, Applegate was appointed to the first board of water commissioners in Red Bank, serving on the commission until 1900.

Applegate could trace his roots in Monmouth County back to 1674, when his ancestor Thomas Applegate Jr. purchased land from the Indians as a signer of the Monmouth Patent. Thomas served on the first General Assembly held in Shrewsbury 1677.

Born in 1837, John Stilwell Applegate attended Madison (now Colgate) University and was admitted to the New Jersey Bar Association in 1861. He served three terms as Shrewsbury's school superintendent, an elected position, starting in 1862. He was one of the incorporators of the New York & Atlantic Highlands Railroad and served as president of the first building and loan association in Red Bank from 1871 to 1875.

In 1872, Applegate became president of the Red Bank Gas Light Company. He was also a founder of the Second National Bank of Red Bank, serving as president from 1875 to 1887. When Red Bank was incorporated in 1871, Applegate became president of its first municipal council. (Courtesy of Red Bank Library.)

Edmund Wilson Sr.

Though his son's fame would eventually surpass his own, Red Bank attorney Edmund Wilson Sr. (left) wielded considerable influence not only in Red Bank but also throughout the state.

Born in 1863, Wilson was the son of Thaddeus and Charlotte Ann Wilson. His father served as pastor of the Presbyterian Church at Shrewsbury for 45 years.

Established by Scottish Presbyterians who began arriving in the area in 1685, the church had been holding religious services since 1705, first in members' homes and then in its own church building. When Wilson Sr.'s father died, he was pastor emeritus of the congregation.

The pastor's son attended Phillips Exeter Academy in Exeter, New Hampshire, and then went on to Princeton University, from which he graduated in 1885. After studying law at Columbia University, he began practicing in the offices of well-known attorney Henry M. Nevius in Red Bank. He was admitted to the bar in 1898 and then entered into a law partnership with Nevius, which lasted until Nevius left private practice to become a circuit judge.

A liberal Republican, Wilson entertained a diverse circle of acquaintances at his home on McLaren Street and was a frequent visitor to the Phalanx, an experiment in communal living that attracted many intellectuals of the time.

In 1902, Wilson Sr. and Nevius served on a committee charged with raising the funds needed to reestablish a Young Men's Christian Association in Red Bank. Wilson ultimately became president of the YMCA Board of Trustees while Nevius became president of the YMCA Board of Directors. Wilson was chosen by the US attorney general William Henry Moody as a special assistant to the justice department during its prosecutions of banking officials in the state who had violated the National Banking Act.

In 1908, Republican governor John Franklin appointed Wilson as the attorney general of New Jersey. Continuing his service under Democratic governor Woodrow Wilson (no relation), Wilson Sr. was the state's attorney general until 1914. Despite his many achievements, Wilson Sr. was long troubled with anxiety and depression and spent some time in a sanatorium during his middle years. In the spring of 1923, he came down with a case of pneumonia and died at home in Red Bank at the age of 60. (Courtesy of Dorn's Classic Images.)

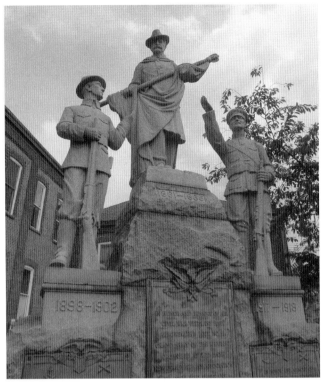

A Civil War Hero

The topmost figure on the borough war memorial on Monmouth Street depicts Henry M. Nevius, a Red Bank attorney, state senator, and judge who was repeatedly honored for heroism during the Civil War.

Sculpted by Frank Manson, the monument is titled "Handing Down Old Glory."

Nevius was involved in many bloody skirmishes as a member of the Lincoln Cavalry and, later, served under General Custer.

Nevius's injuries in battle lead to the loss of his left arm. After the war, Nevius earned a law degree and went into practice in Red Bank with Edmund Wilson Sr.

In 1902, he helped reestablish the Red Bank YMCA and served as president of its board of directors.

Henry M. Nevius died after a brief illness on January 30, 1911, at the age of 70. (Top, author's collection; bottom, courtesy of Red Bank Community YMCA.)

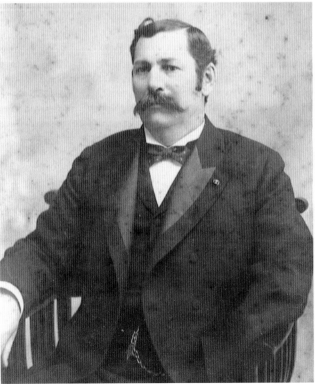

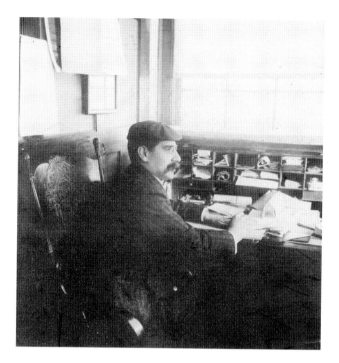

Sigmund Eisner

Among the most influential citizens in the history of Red Bank was Sigmund Eisner, an immigrant who built a manufacturing empire but who also helped build a community.

Born in Bohemia in 1859, he settled in Red Bank in 1881. Starting with a single sewing machine, he built a clothing manufacturing business that outfitted America's soldiers from the Spanish Civil War through World War II as well as for America's allies. He also manufactured Boy Scout uniforms. His main factory was a large brick building on Bridge Avenue, but as the company grew, he added factories in Long Branch, South Amboy, and Freehold. By World War I, Eisner was employing more than 5,000 workers.

He married Bertha Weis, who owned a millinery store on Broad Street, on January 13, 1886. They had four sons who followed their father into business: H. Raymond, J. Lester, Monroe, and Victor.

As Eisner's success expanded, so did his civic and charitable pursuits. He was one of the organizers of the Monmouth County Organization for Social Service, a member of the Board of Governors of the New Jersey State Reformatory for Boys in Jamesburg, and was a generous supporter of many organizations, including the Red Cross and the Monmouth Memorial Hospital (now Monmouth Medical Center) in Long Branch.

He was also active in many Jewish organizations, serving as a trustee of Congregation Beth Miriam in Long Branch and supporting the American Jewish Committee, the Jewish Welfare Board, and the Zionist Committee of America.

His business and financial interests brought him into the company of presidents, governors, senators, and congressmen, but he maintained a personal interest in his employees that was remembered in the memorial book printed upon his death at the age of 66 on January 25, 1925. The book included, "Sigmund Eisner knew and addressed most of his employees by their first names. He took a personal interest in every one of them. He encouraged them to acquire their own homes and in numerous cases helped them to attain this goal. There are more employees in the Eisner factories today who own their own homes than there are in any similar institution in the country." (Courtesy of Red Bank Library.)

1895 Picnic
Eisner family members and friends are pictured enjoying a summer picnic, including (in no particular order) Sidney Salz, H. Kraus, Mr. Goldstein, H. Raymond Eisner, ? Goldstein, Ida Weiss, ? Lev, Irma Goldstein, J. Lester Eisner; J. Salz, ? Albert Weis, ? Sigmund Eisner, Albert Weis Goldstein, Rosa Weis, ? Goldstein, Max Weis, Sigmund Eisner, ? Hirschfield, and ? Sickles. (Courtesy of Red Bank Public Library.)

The Extended Eisner Family
Sigmund Eisner's siblings and their wives are, from left to right, Julie Lederer, Theresa Bloch, Marie Fleischner, Arnold Eisner, Moritz Eisner, Sigmund Eisner, and Daniel Eisner. Sigmund Eisner became a revered and beloved figure in Red Bank. The following was among the many tributes included in his memorial pamphlet: "America never had a more loyal adopted son nor Red Bank a more devoted citizen." (Courtesy of Red Bank Public Library.)

"A Master Builder"

Sigmund Eisner's achievements in business and his reputation for philanthropy created an enduring legacy. In 1937, in memory of their parents, Sigmund and Bertha's children donated the 20-room family home on the river for use as the borough library. The Eisners' great-grandson Gerald Eisner became the head of one of the most American of American enterprises—the Walt Disney Company. (Courtesy of Red Bank Public Library.)

Archiving Red Bank History

Librarian Elizabeth McDermott is the curator of the archives of the New Jersey History Room at the Red Bank Public Library, which contains some 300 years of local and state history. The history room is located in a former bedroom of the home at 84 West Front Street that the Eisner family donated to the borough for use as a library. (Author's collection.)

THE HEAVENS IN NOVEMBER.

A celestial display which may be seen to best advantage on the night of Tuesday, November 5. Elephants and Bull Moose should beware of comets and seek cyclone-cellars. Display will be especially dazzling at Oyster Bay, N. Y., and Beverly, Mass. Visible anywhere in the United States, however, shortly after sundown.

Abram Elkus

Tower Hill Presbyterian Church sits atop a green hillside in Red Bank that was once the estate of Abram I. Elkus, a renowned attorney and public servant who summered in Red Bank throughout his long life and career.

Born in New York City in 1867, Abram Elkus earned his law degree from Columbia College in 1888 and swiftly became a respected trial attorney.

His accomplishments were many, but his proudest moments surely included his service as chief counsel on the New York State Factory Investigation Commission in 1911. On March 25, 1911, a fire broke out in the Triangle Shirtwaist Factory, which occupied three upper floors of a building in the Greenwich Village area of New York City. Locked factory doors prevented the workers from escaping, and 146 people—129 women and 17 men—died in the afternoon blaze, many jumping to their deaths to escape the flames.

The commission he chaired conducted an investigation that extended to 3,000 workplaces throughout the state. As a result of their report, the State of New York adopted the most progressive labor laws in the nation, setting standards for child labor, working hours for women, and occupational health and safety.

Elkus went on to achieve distinction as an associate judge of the New York Court of Appeals. He also served as the US ambassador to the Ottoman Empire in 1916, appointed by Woodrow Wilson during a period of extreme turmoil when he enlisted the Red Cross, Armenian, and Jewish relief services to help Armenian victims of genocide and to alleviate the hardships and starvation of the general population.

Returning to the United States in 1917 after the Turkish government broke off diplomatic relations with the United States, Abram Elkus (pictured at the bottom, center, of the image above) was appointed to the New York Court of Appeals and continued a life of public service until illness forced him to retire. He died at his home in Red Bank on October 15, 1947. Four years after his death, Abram Elkus's daughter Katharine Elkus White became the first woman elected as mayor of Red Bank. (Courtesy of Red Bank Public Library.)

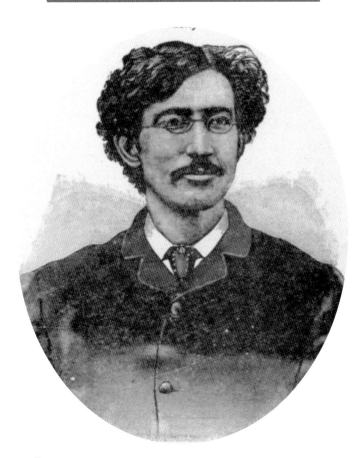

Timothy Thomas Fortune

Timothy Thomas Fortune was already considered the most influential African American journalist of his time when he purchased the 12-room mansion built in the Second Empire style at 94 West Bergen Place in Red Bank in 1901.

Born into slavery on October 3, 1856, in Marianna, Florida, Fortune was delivered from the prospect of a life of slavery when slavery came to an end in Florida in 1865, when he was nine.

Fortune spent a year at Howard University before making his way to Manhattan, where he was hired as a printer at the *New York Sun*, a black newspaper. He eventually moved into an editorial career, serving as editor of the *Globe* and as the chief editorial writer for the *Negro World*, before securing financial backing and establishing a paper of his own, the *New York Freeman*, in 1883. He changed the name of that paper to the *New York Age* in 1887. The *New York Age* was said to have the widest readership of any African American newspaper of its time.

Fortune became an outspoken advocate for workers' rights and for women's rights. He advocated full equality between black and white, men and women, urging the oppressed toward action to secure their civil rights. "Let us agitate! Agitate! Agitate!" Fortune wrote, "until the protest shall awake the nation from its indifference."

Fortune is credited with creating the term "Afro American" to describe those who are "African in origin and American in birth" and with establishing the National Afro American League, a predecessor of the NAACP.

Fortune experienced financial difficulties in his later years as he battled alcoholism and depression. Despite his personal struggles, he continued his crusade on behalf of civil rights. From 1923 until his death in 1928, he served as editor of Marcus Garvey's influential publication *Negro World*. (Courtesy of New York Public Library.)

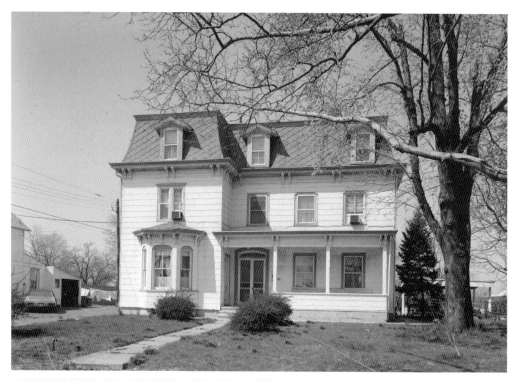

Red Bank, N.J.
Sept 20, 1901

Dear Mr. Myers:

Your letter to the firm was sent me here, here I now have my residence, "far from the mad ring crowd's ignoble strife." The copy of The Age indicated has been sent to you. We are glad the paper is so well liked in your neck of the woods that you have trouble in keeping up with your copy of it.

The tragic death of President McKinley has thrown a damper over everything, and for the present one of us know where we are.

Yours truly,
T. Thomas Fortune

Maple Hall

In the letter at left, Fortune writes to a colleague from his residence in Red Bank, "far from the maddening crowd's ignoble strife." One of the 10 most endangered historic sites in New Jersey, efforts to preserve the home are ongoing. Maple Hall was entered into the National Register of Historic Places in 1976—the only National Historic Landmark in New Jersey that is associated with African American history. (Courtesy of Library of Congress.)

A Crusader for Equality

In an era when the lynching of black men was still common, Fortune used the pages of his newspaper to bring the world's attention to this brutal and inhuman legacy of slavery. He argued that there should be no distinctions made between citizens on the basis of race. He was also an outspoken proponent for women's rights and for labor rights. (Courtesy of the Ohio Historical Society.)

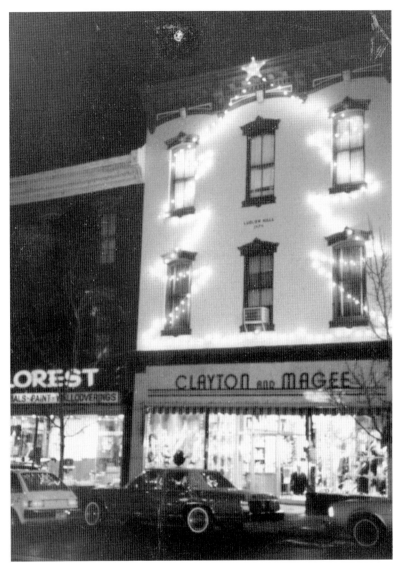

Clayton and Magee

For decades during the 20th century, Clayton and Magee was the place boys went to be fitted for Sunday suits, shirts, pants, overcoats, underwear, and socks. It was the place where men went to select a fashionable overcoat or a custom-fitted suit.

In 1846, a widow named Alice Ludlow opened her men's clothing emporium on Broad Street. It remained a men's clothing store for another 151 years.

After a fire destroyed most of Broad Street in the late 19th century, Ludlow had a new building constructed at 19 Broad Street. The lower floors housed the business, and Ludlow and her daughter Alice lived in an apartment on the third floor.

When Alice married her husband, Henry Supp came into the business, and the family continued operating the men's clothing store there until 1924, when Supp sold the store to Harry Clayton and Eugene Magee. The Magee family eventually became sole owners. The end of the business came in 1997, when Don Magee faced the unhappy task of closing the store that had supported the Magee family for three generations. (Courtesy of Don Magee.)

The First Magee

Eugene Magee Sr. and his partner Harry Clayton purchased the clothing store in 1924. Magee Sr. was chair of the Red Bank Fire Commission, served on the borough council, and was a charter member of the Lions Club. (Courtesy of Don Magee.)

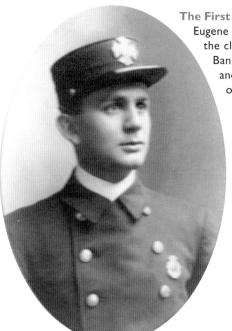

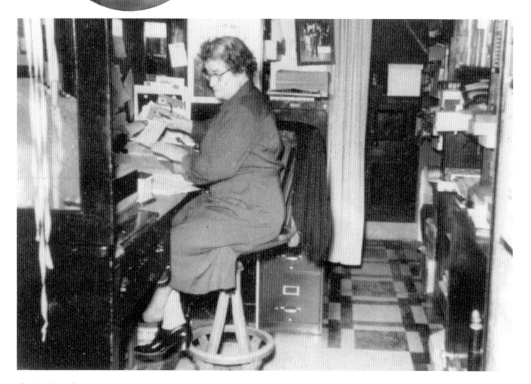

Carrying On

When Eugene Magee Sr. died in 1935, his widow, Elizabeth Magee, handled the bookkeeping for the store while her son Eugene Jr. managed it. To make ends meet during the Great Depression, Elizabeth also worked at Worden Funeral home as a makeup artist for the deceased. (Courtesy of Don Magee.)

Picture on a Pony
Don's father, William Magee, grew up on Irving Place. He joined the family business after military service in Korea and bought a home near his mother's house on Irving Place. William Magee served on the Red Bank Board of Education for 16 years. (Courtesy of Don Magee.)

Three Generations
Don Magee and his father, William, are seen in front of photographs of Elizabeth, William, and Eugene Magee Jr. "We specialized in small-town customer service," Don Magee said. "We knew everybody. We had in-house, personal accounts. You could send your kid in and say, 'Mom told me to get,' and it would be done." (Courtesy of Don Magee.)

Family Business
After earning a graduate degree in American studies, Don Magee returned to Red Bank and purchased his uncle's share of the family business. Magee introduced some humor into his marketing campaigns, as illustrated by this sale advertisement from the early 1990s. (Photograph by Jeff Martin.)

Harry Greenwood

After graduation from Red Bank High School in 1938, Harry Greenwood went to work at Merchants Trust Bank, taking college classes at night.

During World War II, Greenwood served as a crew chief on P-47 fighter-bombers all over Europe. They flew seven missions on D-Day alone.

Returning to Red Bank when the war ended, the bank president who had hired him, Kenneth McQueen, urged him to come back to the bank, promising the bank would pay his tuition for night school if he did. McQueen himself was a native Red Banker whose father had operated a grocery store in town for 45 years. McQueen encouraged Harry to return to a banking career, and Harry did, rising to vice president by the time he retired in 1983. (Left, courtesy of Red Bank Library; below, courtesy of Dorn's Classic Images.)

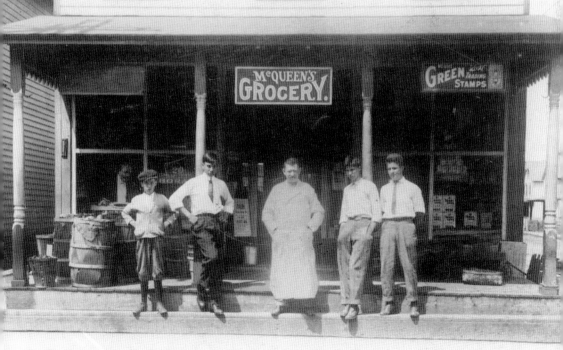

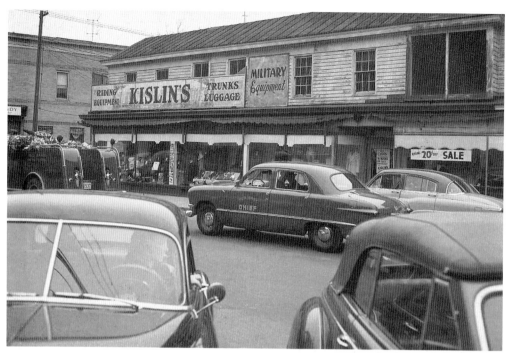

Kislin's

Founded by Leon Kislin in 1908, Kislin's Sporting Goods was in business at 8 West Front Street for nearly 100 years, with sleds, skates, woolen clothing, and a myriad of other items on the menu. Actress Katharine Hepburn was a regular customer. Doris Pinsley succeeded her father, and eventually, her daughter Shaun Pinsley joined the business. The family closed the legendary store in 2005. (Courtesy of Dorn's Classic Images.)

Albert S. Miller

Albert S. Miller Shoes was a fixture in downtown Red Bank for most of the 20th century, but its roots went much further back than that. The store was a direct descendant of the oldest ready-made shoe business in Red Bank, which was founded by John Bergen in 1852. Having started in his teens, Miller became sole owner at the age of 23. (Courtesy of Dorn's Classic Images.)

46

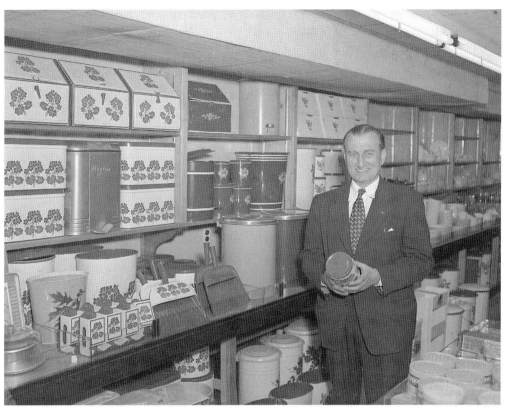

The Prown Family

Max Prown started his five-and-ten-cent store on Broad Street in 1929 with business partner Julius Cooper. In 1929, Prown bought out his partner and expanded the store to six locations around the state. Prown eventually closed all but the Red Bank store. Its slogan, "Prown's Has Everything," was an enduring piece of Red Bank folklore for generations.

After Max Prown's death in 1968, a Prown cousin, Ed Straus, managed the Prown's emporium until he retired in the early 1990s, when Max Prown's grandson David Prown took over as manager. In 2003, Prown (left) closed the Broad Street business and opened Prown's Home Improvement at 135 Monmouth Street. (Above, courtesy of Dorn's Classic Images; left, courtesy of David Prown.)

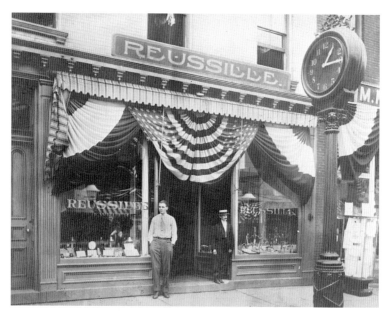

Leon De La Reussille

Swiss native Leon De La Reussille established his jewelry store on Broad Street in 1886 after working in his brother Alfonse's store in Freehold. In 1902, he installed the lollipop clock that still tells time on Broad Street. It served as the official town clock before Red Bank became separate from Shrewsbury Township.

De La Reussille learned watchmaking as an apprentice to his father, and his father's skill was so great that one of his timepieces was exhibited in the Swiss pavilion at the New York World's Fair in 1939.

A passionate gardener, De La Reussille tended many kinds of plants in a garden he kept on the roof of his apartment above the store.

Below, two of Reussille's great-grandchildren, identified only as the Reussille twins, model prom gowns in the windows of Mustillo's on Broad Street in 1957. (Both, courtesy of Dorn's Classic Images.)

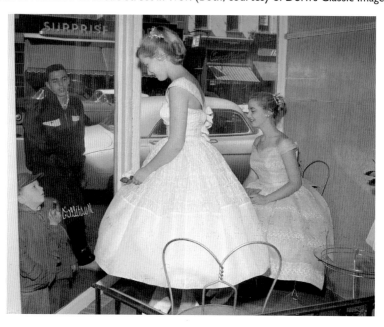

CHAPTER THREE

Society and Service

The people who came to Red Bank had an opportunity to create the kind of community that they wanted to live in: a place to raise a family, to partake of labor and leisure, to build a network of neighbors, and to work together for the common good.

Of course, not everyone agreed on what that common good was—not entirely, and not ever. There were philosophical differences, arguments to be had, battles to be fought, ideas to promote, and other ideas that needed to die. Like any place on earth, it had darkness as well as light.

But with the usual meandering gait that creates progress, the founders of the town and those who followed worked out a way of life that incorporated broader concerns, charitable intentions, and ambitious visions. Their world was a very different one from today's, but no simpler. Theirs was a wilderness on which to craft a community, and a community often requires a club.

The most enduring service organization in Red Bank may be the Community Y, an organization that has evolved dramatically from its roots as a branch of the Young Men's Christian Association founded in England in 1844 to promote Christian values in young men. The first YMCA was established in Red Bank in 1874 when meetings were held in a building owned by William Haddon, a gold-beater (maker of gold leaf) on White Street. That early Y faded away, but after a gap of a few years, a number of prominent Red Bank residents joined together to establish a new organization that would provide young men with a place to play sports and socialize in a Christian atmosphere.

There were some familiar names in this effort to resurrect the Y, like John S. Applegate Jr., Edmund Wilson Sr., Fred W. Hope, Henry M. Nevius, Newton Doremus, John King, Enoch L. Cowart, Robert MacDonald, S.H. Allen, Warren Smock, and Charles H. Ivins. Applegate drew up a certificate of incorporation for the Y in 1904. The Y they built was located on Monmouth Street, just next door to the former Shrewsbury Township Hall. Today's Broadway diner occupies the Y's old spot. Shrewsbury Township Hall was later the Red Bank Borough Hall and police station; it is now part of Red Bank Catholic High School.

As the 19th century made way for the 20th, Red Bank's early residents formed civic organizations that included the Lions Club, the Rotary, and the Elks. The Red Bank Chamber of Commerce (now the Eastern Monmouth Chamber of Commerce) began meeting in Red Bank in 1928.

Women were organizing community-building efforts as well, often focused on those who needed community most. Philanthropist Geraldine Thompson established the Visiting Nurse Association here to provide a healthy start to mothers and babies. Katharine Elkus White spearheaded a canning drive to make sure that people in need had food to sustain them during the Great Depression. Not always, but often, Red Bankers worked together in ways that made life better. They still do.

Walter A. Rullman, MD
Walter A. Rullman, MD, came to Red Bank with a brand new medical degree in 1912 to work as an assistant to Dr. Edwin Field. During World War I, he was assigned to Camp Greenleaf, Georgia. This photograph of Dr. Rullman in uniform was taken in 1918.

In 1929, Riverview Hospital opened in a former boardinghouse on Union Street, with room for 29 patients and six delivery suites. Dr. Rullman became chief of surgeons at the small hospital on the river. He practiced medicine in Red Bank for 50 years, long enough to see Riverview expand into a world-class medical facility, which is now part of Meridian Health System. (Right, courtesy of Red Bank Public Library; below, courtesy of Dorn's Classic Images.)

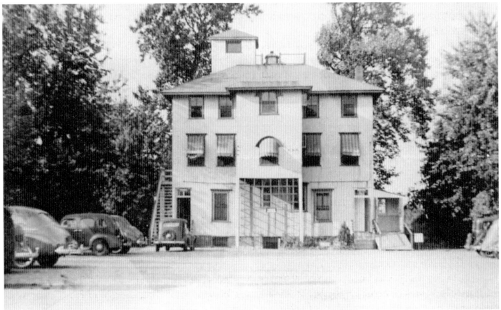

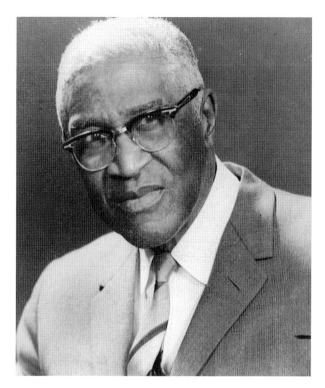

Dr. James W. Parker Sr.

Dr. James Wesley Parker Sr. provided medical care to residents of the west side of Red Bank for more than 50 years, regardless of race, religion, ethnicity, or ability to pay.

Born in Aiken, South Carolina, in 1887, his parents, Stafford and Josephine James Parker, had been born into slavery. Their three sons grew up to become a physician, a dentist, and a pharmacist.

Dr. Parker attended elementary and high school in Jacksonville, Florida, and then worked his way to an undergraduate degree at Howard University in Washington, DC, in 1911. Four years later, in 1915, he completed his medical degree.

He served as a first lieutenant in the still-segregated US Army during World War I. Dr. Parker arrived in Red Bank in 1919 at the time of a deadly worldwide flu epidemic. His caring treatment of flu victims in Red Bank earned him the confidence and respect of those he treated. But because he was African American, he was not permitted to join the staff of the local hospital.

In 1931, Dr. Parker led an initiative to establish a west-side YMCA for African American families who did not feel welcome at the east-side facility. Dr. Parker chaired the finance committee of the West Side Y in the 1950s and remained active in the organization for many years.

Dr. Parker's dedication to his patients and to his community was an inspiration to many. In addition to managing his medical practice from his home office at 172 Shrewsbury Avenue, he was a community advocate who served on the boards of the Monmouth County Welfare Board; the New Jersey State Board of Education; the National Medical Association; the county, state, and American Medical Association; the Monmouth County Organization for Social Service (MCOSS); MCOSS Family Health and Nursing Service; the Red Bank Chamber of Commerce; and the Community YMCA.

During his 56 years as a practicing physician, Dr. Parker received many honors. In 1971, Dr. Parker was honored by the Monmouth and Ocean Chapter of the National Conference of Christians and Jews for his contributions to human relations.

Through his intelligence, compassion, skill, and determination, this son of slaves became one of the most beloved and respected physicians in New Jersey. He died in 1973 at the age of 85. (Courtesy of Red Bank Community Y.)

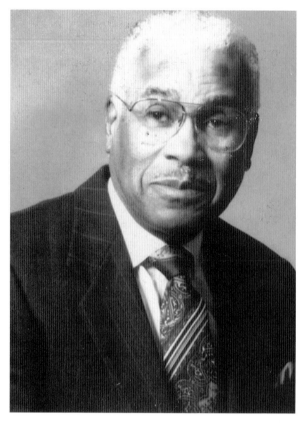

Dr. James W. Parker Jr.

Like his father before him, Dr. James W. Parker Jr. is remembered in Red Bank as a towering example of a caring and skilled physician, civic leader, and role model.

The son of Dr. James W. Parker Sr., the younger Dr. Parker earned his bachelor's and doctorate of medicine degrees at Howard University in Washington, DC. He joined his father's medical practice at 175 Shrewsbury Avenue in the 1950s, after his service in the Korean War, where he was a captain assigned to the battalion aid station on the front line.

During the years he was growing up on Red Bank's west side, the west side was a mixed neighborhood of black and immigrant families, and many of Dr. Parker's father's patients were white. Red Bank's neighborhood schools were not officially segregated, but there were places in town where black and white people were separated. At the movies, Parker recalled in an interview for the *Asbury Park Press*, he was not allowed to sit with his white friends but had to go upstairs to the balcony, the only place in the theater where black people were permitted to sit. One of those theaters now bears the name of Red Bank's most famous native son, William "The Count" Basie, who was a good friend of the Parker family.

Long after white women were having their children in hospitals, black children were being born at home because they were barred from admission to local hospitals. Only when the younger Parker was admitted to practice as a staff physician at Riverview Hospital and Monmouth Memorial Hospital in Long Branch were black women allowed to have their babies in the hospital.

Like his father before him, Parker also took an active role in his community, advocating for the establishment of one Community Y that would serve all residents. He was also a member of the Red Bank Men's Club and many community organizations.

Dr. Parker died in 2004 at the age of 85. Today, volunteer physicians and health care professionals carry on the Parker legacy of compassionate treatment for patients in need regardless of their inability to pay at a clinic named the Parker Family Health Center. (Courtesy of Red Bank Community Y.)

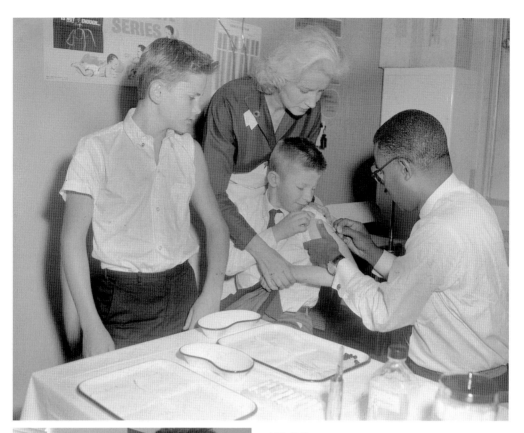

Well Care

Dr. James Parker Jr. administers a smallpox vaccination to a young patient in 1963. Dr. Parker Jr. opened his medical office every day at 5:00 a.m., so families who could not afford to lose a day from work could take care of their health care needs, even if they were not able to pay. (Courtesy of Dorn's Classic Images.)

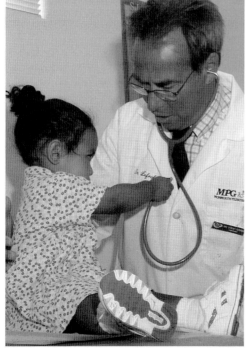

Pediatrician Volunteers at Parker

Dr. Steven Lefrak gets a checkup from a young patient at the Parker Family Health Center at 221 Shrewsbury Avenue. The center continues the Parker family's commitment to provide compassionate care to a new generation of west-side residents as well those in the greater Red Bank area who are unable to afford medical treatment elsewhere. (Courtesy of Parker Family Health Center.)

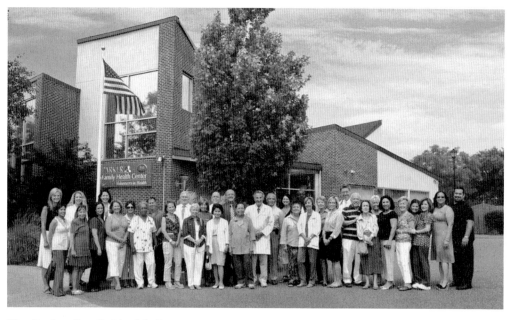

The Parker Family Health Center

Established in July 2000, the Parker Family Health Center is a volunteer-based, free health care facility modeled on the Parker family tradition of compassionate care. Funded by grants and donations (Jon and Dorothea Bon Jovi are generous supporters), the center was founded by a group of health care professionals under the leadership of Eugene Cheslock, MD, an oncology physician at Riverview Medical Center for more than 30 years. The facility now cares for more than 12,000 people each year. (Courtesy Parker Family Health Center.)

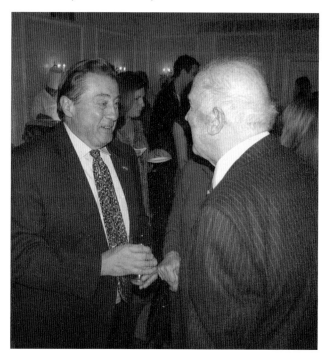

Eugene Cheslock, MD

Eugene Cheslock, MD, talks with a colleague during a 2013 event in the historic Molly Pitcher Hotel. In addition to his work with the Parker Family Health Center, Dr. Cheslock has been an active supporter of many community organizations and charitable efforts, including Holiday Express, Lunch Break and Jon Bon Jovi's JBJ Soul Kitchen. (Courtesy Red Bank Green.)

Katharine Elkus White

When Katharine Elkus White (standing to the left of the seated woman) ran for a seat on the Borough Council of Red Bank in 1933, her opponent, Stanley O. Wilkins, staged a "Keep Katie in the Kitchen," campaign. She lost by 14 votes. But Katie was still cooking.

During the Depression, White ran a vegetable-canning project at River Street School for distribution to needy neighbors. During World War II, she chaired the Red Bank War Bond Committee.

In 1951, she was elected as the first female mayor of Red Bank—an office she would hold through five more years and two more elections.

In 1955, she became the first woman in the United States to head a toll road authority when she was named chair of the New Jersey Highway Authority. In 1964, Pres. Lyndon Johnson appointed her as ambassador to Denmark.

Born in New York City in 1906, White spent much of her childhood at Elkridge, the family estate off Harding Road. Her father, Abram Elkus, served as the last US ambassador to the Ottoman Empire. Her mother, Gertrude Hess Elkus, campaigned for women's right to vote and was active in the Democratic Party. Graduating from Vassar College in 1928 as a speech and drama major, White embarked on a brief acting career that she later characterized as "off-off Broadway."

She married stockbroker Arthur J. White in Red Bank on October 3, 1929, moving into an expanded cottage at Elkridge that had once been White's childhood playhouse. The couple had two children, Lawrence, born in 1931, and Frances, born in 1933.

During World War II, she served as chair of the Greater Red Bank War Bond Drive. She was an active supporter of many social service agencies and causes, among them the YMCA, the United Negro College Fund, the American Association of University Women, the Rutgers University Board of Governors, the Monmouth County Organization for Social Services, and Marlboro Psychiatric Hospital.

White died at her home in Red Bank in 1985 at the age of 78, leaving a legacy of public service that continues to inspire. In the words she used to describe her own role model, Eleanor Roosevelt, Katharine Elkus White "held the torch so high that we . . . will have to work unceasingly to reach the torch and carry it on to greater heights." (Courtesy of Dorn's Classic Images.)

Chester Apy

Retired judge and two-term GOP assemblyman Chester "Chet" Apy has come full circle. He and his wife, Florence, recently moved to the Atrium, a luxury senior citizens complex overlooking the Navesink River on Riverside Avenue. They are the third generation of Apys to retire there.

Their new home is not far from where the old Y building once stood before a new Community Y on Maple Avenue replaced it in the 1960s.

The former Little Silver residents have been supporters of the Y for many years. In fact, when Chet Apy was growing up, Apy's father took his four sons to the Y to play basketball. Strangely enough, the modest height of the Apy men ("none of us were over 5'3'") did not prevent them from scoring big. "My mother was the scorekeeper," Apy jokes.

Nor did height prevent Apy from winning the heart of Florence Pye, whom he met as an eighth grader at Miss Mozar's Dancing School on Prospect Avenue.

The couple shares a strong commitment to social justice and to community service. Florence Apy participated in the March on Washington in 1963. She served on the Red Bank Regional High School Board of Education for many years and was president of the board when it hired Dr. Donald Warner, the district's first African American superintendent of schools, in the 1970s.

A lifelong member of the NAACP, Apy was the attorney for the Y when it went to the Borough Council seeking permission to construct the new Y facility on Maple Avenue, located in the middle of town, making it convenient to everyone. The new Y eliminated a condition of informal segregation evidenced by the existence of a west-side Y serving African Americans and the east-side Y where people of color were not welcome.

He remembers the eloquence of Dr. Parker Sr. Jr. speaking on behalf of a united Y. Apy served as president of the board of trustees of the Y, taking up the challenge of raising the necessary funds to create its new facility on Maple Avenue that would welcome everyone. The Y has come a long way from its roots as the Young Men's Christian Association. Today, men, women, and children of all ages, races, and faiths are members. (Courtesy of Apy family.)

Navesink Nation

Members of the Community YMCA Indian Guides engage in an three-legged race at the Navesink Nation Fun Night in November 1969 Pictured left to right are Daniel Tyler, nation chief; David Hook and his father, Robert Hook; and Alan Loeser and his father, Fred. (*Daily Register* photograph by Don Lordi, courtesy the Red Bank Community Y).

Cotillion

In 1950, members of the west-side Y's women's auxiliary established the Monmouth County Cotillion, a scholarship ball for outstanding African American students. Catherine Foreman was the first cotillion queen in 1951, when 28 young women participated. In 1952, there were 42 debutantes. Red Bank mayor Katharine Elkus White introduced each of them to an audience of 2,300 at Asbury Park's Convention Hall. At left, Florence and Leon Hayes kick up their heels during the 1950s Monmouth County Cotillion. (Both, courtesy of Red Bank Community Y.)

Camp Arrowhead
Kids from the YMCA's Camp Arrowhead hold the giggles long enough to pose on the Maple Avenue site where the Red Bank Community YMCA was being built in 1969. Rhonda Anderson is president and chief executive officer of the Community YMCA. "The Community YMCA has helped impact the lives of close to four generations of Red Bank families, particularly its youth and teens," Anderson said. "We are truly proud of this legacy." (Both, courtesy of Red Bank Community Y.)

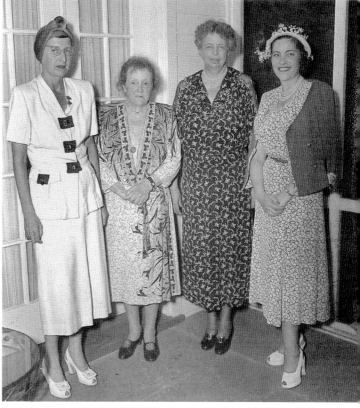

Geraldine Livingston Morgan Thompson

Born in 1867, Middletown's Geraldine Thompson (top image, pictured second from the left) was a wealthy young woman who easily could have enjoyed a life of leisure. Instead, she was a social reformer who worked to improve the lives of mothers and children, effect prison reform, and assist veterans, the elderly, and disabled. The volunteer group she founded in 1912 established its headquarters in Red Bank and eventually became known as the Visiting Nurse Association of New Jersey. Her lifelong friend, Eleanor Roosevelt (top image, pictured third from the left), was a frequent visitor and supporter of the organization. In 2012, the Ellis Island Immigration Museum celebrated the 100th anniversary of the VNA with a special exhibit honoring the organization's work in caring for thousands of immigrant families. Thompson died in 1967 at the age of 100. (Right, courtesy of Dorn's Classic Images; below, courtesy of Library of Congress.)

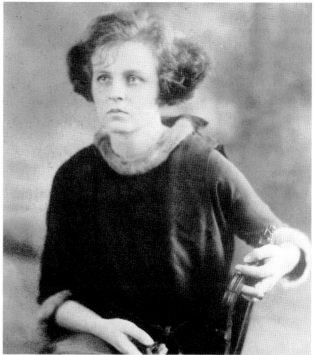

Benedict R. Nicosia

Born in Brooklyn, retired Superior Court Judge Benedict R. Nicosia (left) moved to Red Bank at the age of three. Now 93, Nicosia qualifies as a native by virtue of his record of service to the town that spans well over half a century.

A member of the Red Bank High School class of 1939, Nicosia, like many of his generation, put his personal plans on hold during World War II when he served in the US Army Military Intelligence Division in London and then the Signal Corps.

Following the war, he finished college and law school at Rutgers University, then returned to his hometown to practice law with the firm of Quinn, Doremus, McCue & Russell. He became a partner in the firm Russell, Fasano, Nicosia & Goodall in 1956.

Nicosia was elected mayor of Red Bank in 1960, a post he held until 1968. Gov. Brendan Byrne appointed him to the superior court in 1981, where Nicosia served in the family, civil, and criminal courts.

Nicosia, who has mentored many aspiring lawyers, including Red Bank's former mayor Edward J. McKenna Jr. (right) and Red Bank councilman Michael Dupont (middle, pictured at a Western-theme fundraiser), also knows his way around the kitchen. He is the author of two family-style Italian cookbooks. (Courtesy of Edward J. McKenna Jr.)

Honors for an Extraordinary Woman

For 25 years, Norma Todd was the executive director of Lunch Break, a food pantry and soup kitchen that has served as a lifeline for needy families in the Red Bank area.

The idea for the organization was generated in 1983, when five people gathered at the Friends Meetinghouse in Shrewsbury to confront the reality of hunger in their community. This small group decided to do something about it and established a grassroots effort to provide families with groceries and other needs.

Starting out in the basement of St. Thomas Episcopal Church, they were able to serve hot lunches to hungry members of the community. With the help of a state grant and the generosity of the community, the organization, now known as Lunch Break, was able to move to its own facility on West Bergen Place (now Drs. James Parker Boulevard).

With the help of a large cadre of volunteers, Norma Todd continued to work at Lunch Break well into her eighties. Todd died in 2008, leaving a record of compassionate service that will long be remembered.

The work of Lunch Break continues under the leadership of executive director Gwendolyn Love, her staff, and more than 1,500 volunteers. (Courtesy of Lunch Break.)

State Senator Jennifer Beck

Sen. Jennifer Beck ran for a seat on the Red Bank Borough Council in 1998, declaring her intention to work "for the whole town, not the downtown," at a time when some residents felt their concerns were being overlooked in favor of the concerns of the business community. She was the first Republican to hold office in Red Bank in 10 years. Beck served on the council for six years, leaving in 2005 after her election as a state assemblywoman. She was elected to the New Jersey Senate in 2008.

Beck has received numerous honors during her career, including the Barbara Boggs Sigmund Award from the Women's Politic Caucus in 2008 and the Millicent Fenwick Award for Public Service. In 2008, Senator Beck was also honored when she was one of 24 elected public officials across the country selected to receive the Aspen Institute's Rodel Fellowship in Public Leadership.

During a recent workshop on "Running and Winning," an annual event for high school students aimed at encouraging young women to enter politics, Beck advised young women interested in a political career to forge ahead despite the obstacles.

"If you really feel passionately about something and are very committed, don't let anyone talk you out of your dream, because hard work and your own personal commitment will carry you through a lot," she told the high school students.

Senator Beck is president of JAB Marketing, a media relations and marketing firm. She is also a trustee with the Monmouth Conservation Foundation, a member of the Red Bank Women's Club, and formerly was a rape crisis counselor at what is now 180/Turning Lives Around. (Courtesy of Sen. Jennifer Beck.)

Drew and Kathy Horgan

By the time Drew and Kathy Horgan (right) arrived in Red Bank, they had seen a lot more of the world than most people ever do. Drew's career in developing democracies and government relations had taken them around the world. But some 30 years later, when they were ready to enjoy life in a small town, Red Bank was the one they chose. They bought a Red Bank Victorian that had recently been restored and set about the business of small-town life.

While Drew had worked in government all over the world, he still enjoyed it enough to start attending council meetings and joining civic organizations like Preservation Red Bank (PRB). In 2003, PRB honored Drew Horgan for his "unflagging dedication and spirited counsel in maintaining the historic fabric of Red Bank." Historic preservation was one of the many small-town issues that Drew embraced. "Local government was his passion," Kathy recalled recently.

Kathy was working in New York City, so it was Drew who was putting down the kind of roots that went deep and held fast. Those were the roots that Kathy clung to in 2003 when Drew suddenly became ill and very swiftly died of undiagnosed colon cancer at the age of 63.

He had been home on leave from his latest government mission, working in Iraq to help the local population restore a stable government. When Drew died, Kathy received letters and e-mails from all over the world. At his wake, Kathy received condolences over and over from Red Bankers she had never before met. The town that Drew had embraced so readily embraced Kathy in return.

"People reached out to me, to give me opportunities to volunteer," she recalled recently. "The Monmouth County Arts Council, the Kaboom Committee, the Jazz Arts Project, the zoning board. (I said, what's the zoning board?)"

In 2007, Kathy ran successfully for her first seat on the borough council in Red Bank. The girl who dreamed of adventure is home. "I'm here forever," she says now. (Courtesy of Kathy Horgan.)

Florence Forgotson Adams

Florence Forgotson Adams was a pioneer in a profession that few women entered back in 1929 when she graduated from New York University School of Law.

Her father had wanted one of his sons to become a lawyer, but Florence was the only one of his 11 children who expressed interest in the profession. She was on her way to Freehold, where someone recommended she start her practice, when she got lost and ended up in Red Bank.

She was the first, and for many years, the only female lawyer in Monmouth County. She practiced alone because no one would hire a woman lawyer.

A member of the Eastern Monmouth Area Chamber of Commerce (EMACC) for many decades, Forgotson enjoyed her role as mentor and role model to younger women and generously supported the organization's scholarship fund for returning students.

A lover of hats, feminine, and flamboyant, Forgotson was a tough cookie when it came to the practice of law. She had to be. As she said once, "The boys weren't too kind."

Though she lived in Shrewsbury for half a century, Forgotson Adams was always active in Red Bank, where she kept her law practice. She was a member of the Women's Club of Red Bank, the Red Bank Chapter of Hadassah, and the Eastern Monmouth Chamber of Commerce, among other organizations.

She finally moved to a home on the Navesink River in Red Bank when she was in her eighties. During her years as a member of EMACC, she was a generous contributor to the scholarship fund that provided money for nontraditional students to pursue college, graduate, or vocation school.

The first woman ever admitted to the Monmouth County Bar Association, Forgotson Adams was a trailblazer who paved the way for all the women who followed her into the legal profession in Monmouth County. (Courtesy of Eastern Monmouth Area Chamber of Commerce.)

Danny Murphy

For more than four decades, Red Bank restaurateur Danny Murphy (right) has been an advocate for Red Bank, its restaurant community, and particularly the west side.

Once, his restaurant on Bridge Avenue was an outpost on the fringes of the borough's business district. Today, the restaurant is center stage as a new luxury apartment complex rises around it. Across the street from Danny's, the Galleria Building (once the Eisner Uniform Factory) draws shoppers and diners, and the farmers' market brings people into town on Sundays. The Two River Theater is just steps away, and the train station is an easy walk.

A Red Bank native, Danny grew up in the food business. His mother, Mary Murphy, owned the Friendly Luncheonette on Front Street in the 1950s. And though Danny trained as a court reporter, his affinity for the restaurant business inspired him to open Danny's on Bridge Avenue in 1969.

Danny's started out as an Italian restaurant, making the kinds of dishes Danny's mother learned from her Italian immigrant mother. The restaurant gained a reputation as a sophisticated hangout and drop-in place for famous people playing area venues.

Danny has reinvented his restaurant numerous times over the years to keep things interesting while catering to an ever-changing, ever-more sophisticated clientele.

He was among the first to introduce a sushi bar to his restaurant, and his introduction of high-end steaks led to the restaurant once known as Danny's Italian Restaurant being renamed Danny's Steakhouse.

Over the years, he has worked hard to help Red Bank reinvent itself, too—serving on committees, donating catering services, and holding networking sessions for businesses that, as Danny believes, can only succeed by working together. (Courtesy of Danny Murphy.)

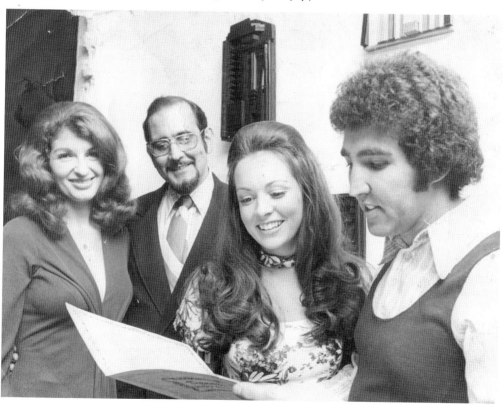

N.Y. STRIP STEAK SANDWICH
GRILLED ITALIAN SAUSAGE SANDWICH
PASTAS AND PASTA SALAD
HAMBURGERS

Danny's STEAK HOUSE & PASTA GRILL

The Original Riverfest

At various times a member, board member, and volunteer for the Eastern Monmouth Chamber of Commerce, Danny Murphy was one of the original founders of Riverfest, a food festival in Marine Park that began in 1980 as a way to advertise the offerings of Red Bank restaurants in a casual setting. The festival returned to Marine Park under the sponsorship of the EMACC three years ago. (Courtesy of Danny Murphy.)

Before It Was Danny's

Pictured in the 1940s or 1950s is the exterior of the building that became Danny's Steakhouse. To the right of that building is Blaisdell Lumber Company, a venerable Red Bank business that endured into the 1990s, when the Blaisdell family sold their property to Robert Rechnitz for development as the Two River Theater Company. (Courtesy of Danny Murphy.)

Lynda Rose and EMACC

Rumson-born Rose is the president and chief operating officer of the Red Bank–rooted Eastern Monmouth Area Chamber of Commerce, founded in 1928. EMACC is one of Monmouth County's oldest business organizations and a proven resource for generations of business owners in the Red Bank area. Though many folks have misconceptions about the role of the chamber—no, it is not taxpayer-funded, and no, it is not the Better Business Bureau, Lynda points out—what it does do is tremendously important to the health of the business community. Among its concerns are monitoring legislation and staying in touch with leaders in business and government to alert members to any information that may affect their business, sponsoring educational and networking opportunities to give members the most relevant information about doing business better, and assisting them with the nuts and bolts of business ownership in the 21st century. (Courtesy of Eastern Monmouth Area Chamber of Commerce.)

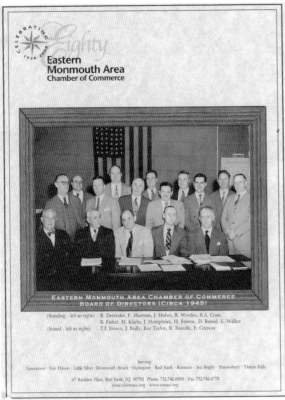

Red Bank Chamber of Commerce, 1945
In 1945, the number of board members exceeded the entire membership of 1928. Pictured are, from left to right, (sitting) T.I. Brown, J. Bailly, Ray Taylore, R. Reusille, and E. Conway; (standing) R. Deirioder, P. Sherman, J. Huber, R. Worden, B.A. Crate, B. Parker, M. Klarin, J. Humphries, H. Farrow, D. Russel, and K. Walker. (Courtesy of Eastern Monmouth Area Chamber of Commerce.)

EMACC, 2013
Now more than 85 years old, the Eastern Monmouth Area Chamber of Commerce has more than 700 members representing 150 business categories, all of whom are actively involved in promoting Monmouth County as the perfect place to live, work, and play. (Courtesy of Eastern Monmouth Area Chamber of Commerce.)

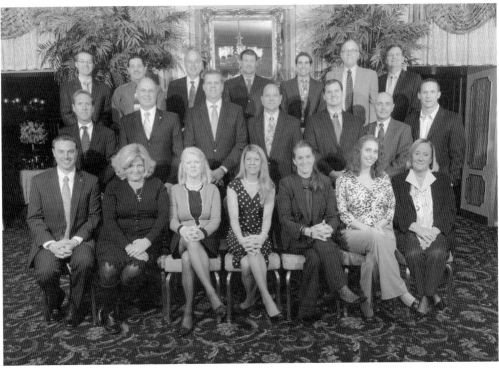

CHAPTER FOUR

Hearts in the Arts

Red Bank has always marched to the beat of a different drummer—in fact, many different drummers.

This is the home, after all, of William James Basie, a jazz musician, bandleader, and composer who is known worldwide as America's ambassador of jazz. The piano that stood in his parents' living room on Mechanic Street took him to the heights of the musical world. Long before Basie got there, though, a fellow Red Banker took advantage of another fledgling art form—traveling around the East Coast making films that starred local folks, which guaranteed a crowd when the movie debuted in its hometown theater.

The Dorns were also masters of the still photograph, and the images they preserved have given Red Bank a visual record of its history that is beyond priceless. The town has long been a hub for artists of all stripes, from the Wednesday Night Study Group, who painted together for 30 years at the Art Alliance on Monmouth Street, to illustrator James Avati, who used townspeople as models for the book covers he created.

Theater, too, has held a special place in the history of Red Bank, from the days of vaudeville and silent films to the present. The Count Basie Theatre started out in the 1920s as a vaudeville palace and silent movie theater. Legend has it that Basie himself played along on piano for some of those silent films.

Joan and Bob Rechnitz chose Red Bank as the home of their professional theater, Two River Theater Company, elevating the local theater scene with their intelligent, carefully chosen productions.

Norman Seldin, whose family owned Seldin's Jewelers when he was a child, was already a working musician and rock promoter in his teens, bringing in Motown bands and British invasion rockers for local appearances while featuring his own bands like the Motifs and Joyful Noyze in clubs throughout the area.

Around the same time, Bruce Springsteen was playing high school dances with his band, the Castiles. And as the 1970s and 1980s arrived, Red Bank gave birth to one of the hottest rock clubs around, Big Man's West, the rock club Clarence Clemons opened on Monmouth Street. Big Man's West endured only a few years, but it left its mark in the hearts—and on the careers—of the young local musicians who had a chance to play there.

Red Bank is a town full of music but also a town full or artists, photographers, writers, actors, dancers, and the people who appreciate them. Art and soul–these are two of Red Bank's most legendary locals.

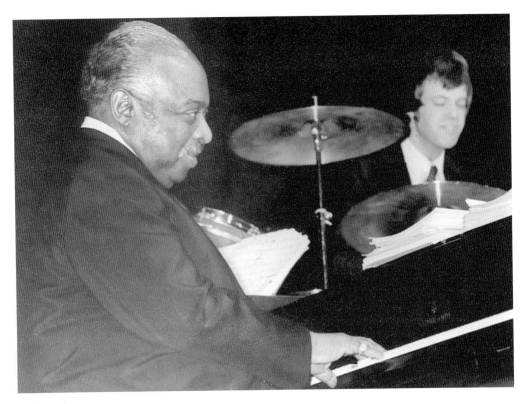

William "The Count" Basie

The world's most famous master of swing first fell in love with music in his hometown of Red Bank.

Born on August 21, 1904, Basie's parents were Lillian Ann Childs Basie and Harvey Basie. His mother played the piano. His father played the mellophone. An only child, Basie took his first piano lessons from his mother, and from then on, his path was pretty much set. By his teens, he was traveling to Harlem, where his musical education was enhanced by his friendship with famous jazz pianist, composer, and organist Fats Waller.

Basie started off playing as an accompanist for movies and vaudeville acts, but before long, he was playing in big bands. By the 1930s, Basie had achieved renown as one of the foremost bandleaders of the jazz era. Among his most famous numbers was "One O'clock Jump," which Basie had written himself. It was during an appearance at the Reno Club in Kansas City that Basie earned the nickname, "The Count." A small radio station was broadcasting the show, and the announcer decided to add some spark to the name "Bill Basie," by giving him a title.

With its original arrangements and solos featuring the best musicians in the business, the Basie orchestra was crowned "the epitome of swing; performing jazz compositions that one critic described as putting "wheels on all four bars of the beat."

Radio broadcasts and recordings helped to spread Basie's particular brand of jazz far and wide, leading to larger performances and bigger crowds in cities like Chicago and New York. Over the decades, Basie's stature as revolutionary jazz musician continued to grow. In 1960, the Basie band performed at the inauguration of John F. Kennedy. In 1981, he received the Kennedy Center honors for achievement in the performing arts, the highest arts award given in the United States.

A bust of Count Basie can be found at the Red Bank Train Station, and a portion of Mechanic Street carries the honorary title "Count Basie Way." But the greatest memorial to Basie in Red Bank remains the former Carlton Theater, renamed to honor "the kid from Red Bank" in 1984, after Basie's death at the age of 79. (Courtesy of Dorn's Classic Images.)

Homecoming Concert

In 1938, Count Basie returned to his hometown with his "15-piece Negro band" to present a fundraising concert for the west side Y. Basie was already very famous at the time and so was one of his featured performers, Billie Holiday. (Courtesy of Red Bank Community Y.)

J., SATURDAY, JANUARY 29, 1938.

Red Bank Westside Y.M.C.A. Presents Count Basie's Band

RED BANK, Jan. 29. — Count Basie and his 15-piece Negro band will make their first appearance here on Thursday night, Feb. 3, at :30 o'clock when they will present concert and dance at the River Street School auditorium. The entertainment is under the auspices of the Red Bank Westside Young Men's Christian Association.

Count Basie, a native of Red Bank, is being brought here through the efforts of Dr. James W. Parker, chairman of the Westside Y. M. C. A. and the Board of Directors. Count Basie or William as he was known in his schooldays is a son of Mr. and Mrs. Harvey Basie of 229 Mechanic Street. He was born at Red Bank, studied music here since he was seven years old and attended the Red Bank High School.

He started on the road to fame with a small orchestra, making his first appearance at a small dance at New York. He was in New York about two weeks and then made a tour of the West.

The history of Count Basie's band starts in 1934 in Kansas City, just after the death of Bennie Moten. The great Negro bandleader, Basie had been Moten's pianist and assistant conductor, so that it was logical that he assumed command of the band after Moten's death. For nearly two years, he directed the band at the Reno club in Kansas City.

One of his broadcasts from this spot attracted the attention of Benny Goodman, who was at that time playing at the Congress hotel, Chicago. Goodman seldom missed the band's broadcasts from that time on and became Basie's staunchest booster. Through his recommendation, the band was signed by the Music Corporation of America, which immediately brought the band into recognition.

Red Bank will start promptly at 8:30 o'clock and will continue until 10 p. m. From 10:30 p. m. to 1 a. m. Count Basie and his sensational band will play for dancing.

He and his orchestra made their first appearance in the county last August when they played a concert at the Elk's home, Asbury Park. Their concert was well applauded and by a capacity crowd which was on hand to welcome the famed Red Bank musician.

Features on his program are Billie Holiday and James Rushing. Miss Holiday is considered probably the finest girl swing singer of her race, and Mr. Rushing, whose renditions of popular songs in swing tempo have been heard on many of Benny Goodman's Victor recordings.

Harvey Basie

Harvey Basie, father of William "The Count" Basie, stands in the ruins of the family home at 229 Mechanic Street near the family piano. According to informal accounts, Count Basie arranged to build a new home for his parents after the family home was damaged in a fire. (Courtesy of Dorn's Classic Images.)

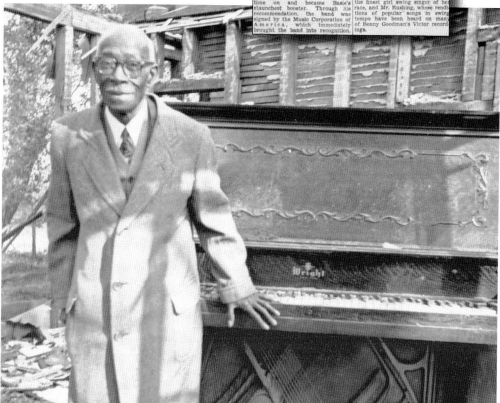

Robin Shannon

Growing up in the former home of the Basies at 229 Mechanic Street, Robin Shannon was worried that she might bump into Count Basie's ghost. Eventually, she confided her fear to her mother, who told her, "Honey, he's not dead."

Mechanic Street is on the east side of town, which is largely white. Shannon's friends were black and white, but she does not recall race being a major topic of conversation as they played with their Barbie dolls.

But as she grew older, Shannon encountered assumptions about black and white, east side and west side, that she certainly contemplated as she established her own sense of character and identity and her own aspirations.

Though she studied flute and was in the band in high school, Shannon does not claim to have absorbed any extraordinary musical talent from living in the Basie home.

She had originally intended to focus on filmmaking, but while earning her degree at Morris Brown College in Atlanta, she took a class with a former professor of Spike Lee's. "My film was horrible," she laughs.

Fortunately, she had another passion.

"I remember wanting to be a journalist when I was young," she said. "I wanted to be like (former NBC news anchor) Sue Simmons. I remember thinking, 'They just know everything!'"

"I always have so much pride in Red Bank—I love it," says Shannon, who is now surely influencing some other little girl to consider a career in broadcasting, just as Simmons influenced her. "It was very safe. The neighbors actually looked out for each other. If you were out playing and it was getting dark, the neighbors would say, 'The streetlights are going on, you better get home!' Now as an adult I realize how much that community meant." (Courtesy of Robin Shannon.)

Robin Shannon, WFUV
Though she may not perform it herself, Robin Shannon, a broadcast journalist and assistant news and public affairs director for WFUV radio in New York City, is never far from the music. After getting her start in the business as an intern at WBJB-FM at Brookdale Community College, she was soon hired full time and was well on her way to a career with a multitude of highlights over the past 20 years. (Courtesy of Robin Shannon.)

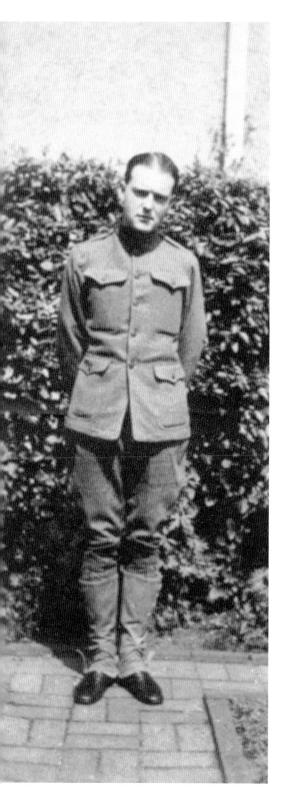

Edmund Wilson Jr.

Journalist, critic, and author Edmund Wilson is linked with some of the most famous literary lights of the 20th century. Among his famous writer friends were F. Scott Fitzgerald, Edna St. Vincent Millay, Anais Nin, Vladimir Nabokov, and Mary McCarthy, who became his third wife.

During his career, Wilson was managing editor of *Vanity Fair*, associate editor of the *New Republic*, and a book reviewer for the *New Yorker*. His works of fiction and nonfiction include *Memoirs of Hecate County*, *To The Finland Station*, and *I Thought of Daisy*.

Throughout his life, Wilson returned to Red Bank often to visit his mother and to see his childhood friend, Margaret Edwards Rullman, with whom he maintained a lifelong friendship.

Born in Red Bank on May 8, 1895, Wilson's father, Edmund Wilson Sr., was a prominent attorney who served as the state's attorney general from 1908 to 1914. The family lived in a large house at 100 McLaren Street, and in a 1967 interview with the *Daily Register*, Rullman shared memories of childhood days with the Wilsons. The Wilson family had a large Christmas party every year during which they lit candles on the family tree as a few uncles stood by with buckets of water just in case.

Wilson's father was a liberal Republican who entertained a diverse assortment of acquaintances in the family home, and on Sundays, he took the children to visit the Phalanx Community, an experiment in communal living that had established itself a few miles from Red Bank. Alexander Wolcott had been born there, and he remembered the two children, Wilson and Rullman, making his acquaintance. Wilson's mother, Helen Mather Kimball, was made of sterner stuff; she was a descendant of Cotton Mather, a Puritan minister who was an influential advocate for the prosecution of those accused in the Salem witch trials. The childhood companionship between Wilson and Rullman ended when they were about 12, as they both went off to private schools. But Rullman could still recall a few of the special gifts they exchanged. One Christmas, Wilson gave her a copy of *Alice's Adventures in Wonderland*. And when Wilson was about to go to Europe for the first time around the age of 12, Rullman gave him a journal to keep. He continued keeping a journal all his life. He died in 1972 at the age of 77. (Courtesy of the Wilson family and Beinecke Library, Yale University.)

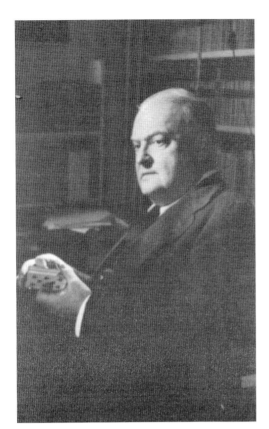

Edmund Wilson in Later Life
A reluctant soldier, Wilson served as an Army nurse in England and France during World War I and later drew on that experience in his book *I Thought of Daisy,* writing, "After a time, after his first physical sinkings of nausea and fear, he had been able to line up corpses on the floor of the field hospital with less emotion than he had once arranged books on the shelves of his bookcases at college." His war experience made him a lifelong pacifist. (Courtesy of the Wilson family and Beinecke Library, Yale University.)

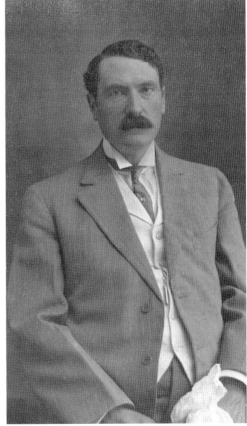

The Senior Wilson
Edmund Wilson Sr. was a respected lawyer and politician who served as attorney general for the state of New Jersey. Despite his achievements, Wilson suffered from periodic bouts of depression. After his death at the age of 60, his widow, Helen Kimball Wilson, moved to a home on Buena Place that years later was purchased and renovated by former mayor Edward J. McKenna Jr. (Courtesy Red Bank Public Library.)

Evelyn Leavens

As a little girl, Evelyn Leavens used to pronounce her name as "Eleven Lemons." An only child, she lived the better part of her 88 years in the home her parents built on Alston Court around 1930. The property had been part of the old Blaisdell estate.

The family traveled to Europe during the Great Depression as a means of conserving their cash during those difficult financial times, and one of Leavens's most treasured memories was an impromptu dance with Albert Einstein in a small village where, bored with the grown-ups, he entertained himself by playing with the children.

Leavens displayed her extraordinary artistic talents from a very young age. "As soon as I was able to move my fingers, I was drawing," she said. "I was born that way."

Fun-loving and beautiful, Leavens did not lack for suitors as a young woman, but her heart belonged to art, and she dedicated her life to that passion.

Frequently outspoken, opinionated, and eccentric, Leavens was beloved by her fellow artists and the many hundreds of children she introduced to art during the lessons she held in the basement of her home. She had her first solo show at the Old Mill Gallery in Tinton Falls, which was then a mecca of the fine and performing arts where famous names, like Alice Neel and Martha Graham, displayed their talents.

In 1958, Leavens herself became famous as the author of the book, *Boswell's Life of Boswell*, published by Simon and Shuster, which featured whimsical caricatures of her basset hound, who, among other things, enjoyed disrupting the cocktail hour. The book rose to number two on the *New York Times* Best Seller list in the children's book category; although, its sophistication made it a favorite with adults.

Leavens was always working and always in demand. Her style ran the gamut from abstract to realistic and from quirky and eccentric to beautiful and detailed. "I never had a job in my life," she said recently. "But when I worked, I worked hard. That was my job."

Leavens died on April 3, 2013, not long after her interview for this book. She dismissed the fact of her illness with the same defiance that wedded her to her work—she would much rather talk about art. To paraphrase the poet Robert Frost, she had ideas yet that she had not tried. (Courtesy of Dorn's Classic Images.)

Self-portrait

Leavens's was as adventurous in her painting and drawing as she was in her life, and her work spanned many genres, media, and styles. This self-portrait, completed in 1977, is a favorite of her friend and former student, artist and gallery owner James Yarosh. (Courtesy of Yarosh Collection.)

Judy Martin

On a rainy Saturday evening, artist Judy Martin is enjoying a glass of wine and talking about Lucian Freud, the painter she most admires.

What she does not realize, says her friend and art dealer, James Yarosh, is that she is Red Bank's Lucian Freud—an extraordinary painter and an extraordinary mentor and friend. "Everybody is constantly becoming," says Martin. "I'm still becoming."

Now 81, Judy is one of the legendary locals who paints their lives in broad strokes on a canvas that captures the world.

Considered "a painter's painter," Martin has a passion for painting people, and while her work is admired far and wide, she dismisses the praise by saying, "I'm an illustrator. I'll always be an illustrator."

The daughter of a mill owner in Camden, Massachusetts, Martin is the mother of four children. For more than 30 years, she was a part of the Wednesday Night Study Group at the Monmouth Art Alliance on Monmouth Street, where artists gathered to paint from a live model who was also an integral part of the group.

Still pondering the problems of art with brush in hand in her eighth decade, Martin is full of wisdom—but then again she seems to be a woman who always was. "It's a good thing for a painter to be able to pay the bills," she says. "But they shouldn't have a lot of money. You should probably always run a deficit because you are always moving forward." (Courtesy of James Yarosh.)

Lifelong Friendship

Judy Martin (seated) and Evelyn Leavens (standing) were talented travelers in the tribe of the artist, sharing a lifelong friendship that allowed for the occasional abrupt hanging up of the phone and the regular antidotes to anger of laughter and understanding. "A bad day is not the end of the world," says Martin. ("Two artists at the end of the Day" by Judith Martin, courtesy of James Yarosh Gallery.)

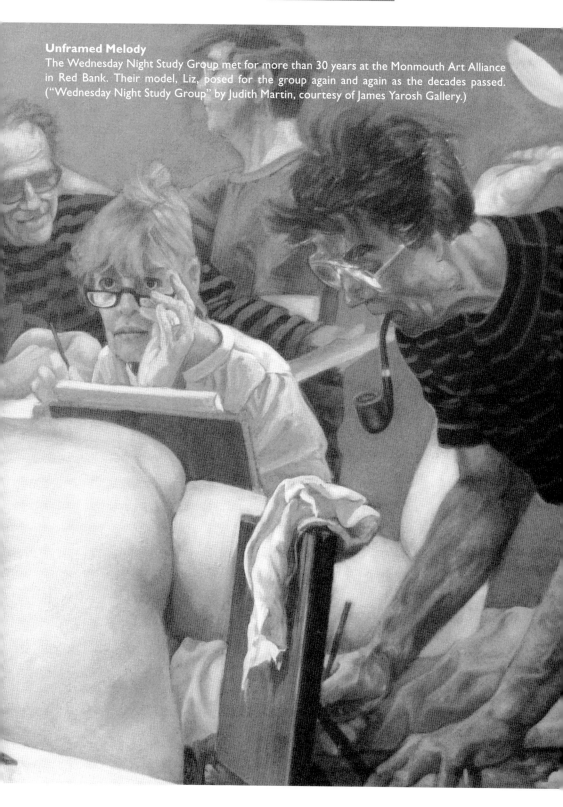

Unframed Melody
The Wednesday Night Study Group met for more than 30 years at the Monmouth Art Alliance in Red Bank. Their model, Liz, posed for the group again and again as the decades passed. ("Wednesday Night Study Group" by Judith Martin, courtesy of James Yarosh Gallery.)

Mary Eileen Fouratt

Since 1997, Mary Eileen Fouratt has been at the vortex of the Monmouth County arts community, working to create a synergy between the arts, education, economic development, and everyday life in her role as executive director of the Monmouth County Arts Council (MCAC).

The Red Bank–based organization serves more than 75 arts organizations throughout Monmouth County. The organization has substantially increased its revenues and more than doubled in size during her tenure, winning acclaim as one of the best county arts agencies in the state.

The organization was established in 1971 with seed money from the Junior League of Monmouth County and the New Jersey State Council on the Arts.

Its mission was to function as a central resource for artists and arts organizations, enhancing the quality of life in Monmouth County by supporting the artists whose works celebrates, enlightens, and educates the community.

A graduate of the College of Holy Cross, where she earned her bachelor's in history, and Bank Street College of Education, where she earned her master's in museum education, Fouratt came to the MCAC with a broad understanding of the function and importance of the arts in the daily life of the community.

She has worked for many history and arts organizations over the years, including the Monmouth County Historical Association, the Monmouth Museum, and Longstreet Farm. Fouratt has consulted with the Newark Museum, Ocean County Historical Society, Historic Allaire Village, Lefferts Homestead, and Cold Spring Village. She designed the first history Discovery Room in New Jersey for the Monmouth County Historical Association.

During her tenure, MCAC received the highest grant of any county arts agency from the New Jersey State Council on the Arts for 13 years. The Monmouth County Arts Council has received a Citation of Excellence from the New Jersey State Council on the Arts from 2006 to 2014.

A Challenge Met

When Numa Saisselin accepted the position of chief executive officer of the Count Basie Theatre in 2002, he had a big challenge on his hands. The once-proud vaudeville theater, movie palace, and arts venue was in dire need of not only a face-lift but also a complete makeover. The theater had been running in the red for several years, and while the Basie was a favorite with locals and touring performers alike, it needed some major attention.

Now one of the crown jewels of Red Bank, the historic Count Basie Theatre had been rescued from the wrecking ball through an anonymous donation that made it possible for the Monmouth County Arts Council to buy it for less than $100,000 in 1973.

Opened in 1925, it was originally called the State Theater. Generations of Red Bankers remember it as the Carlton—a place to enjoy a Saturday matinee.

The Monmouth County Arts Council operated the theater as the Monmouth Arts Center until from 1973 to 1984, when it was rechristened in honor of Red Bank's most famous native son, William "The Count" Basie.

The theater became an independent nonprofit in 1999, and work began on mustering the support to restore the crumbling edifice to its original glory. Under the leadership of former Basie chief executive officer Numa Saisselin and with the support of a dedicated foundation and board of trustees, the Basie embarked on a $21.5-million, multiyear renovation that got under way in 2004.

Now listed in the National Register of Historic Places, the Basie was again a thing of beauty, its budget was in the black, and its status as a mecca for the performing arts was revived. More than 200,000 people each year now enjoy performances at the Basie. Falling plaster and leaking roofs are well in the past, and the newly beautified Basie had tripled its audience numbers and enjoyed nine years of cash surpluses.

While Saisselin has moved on to become president of the Florida Theater in Jacksonville, Florida, the Basie's restoration is an example of what can be accomplished when a group of determined people work together for a worthy cause. (Courtesy of Numa Saisselin.)

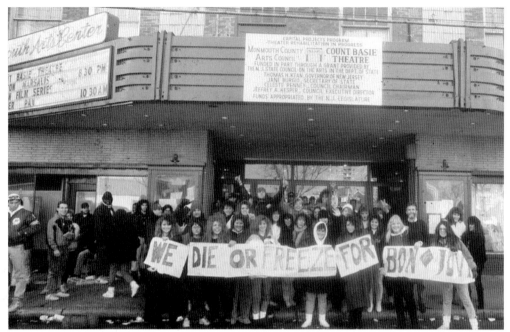

In Need of a Makeover

The Basie was showing its age in the 1980s when these Bon Jovi fans gathered outside to welcome their favorite rock-and-roll star. Even in its neglected state, the Basie was the scene of some mighty performances over the years, from screen legend Cary Grant to world-class crooner Tony Bennett and world-famous local legends like Jon Bon Jovi, Bruce Springsteen, and Southside Johnny. (Photograph by Mark Weiss.)

Doing Good Together

In April 2013, the Count Basie Theatre hosted a benefit that raised more than $400,000 for local charities that helped Hurricane Sandy survivors. Gwendolyn Love (front, center), the executive director of the Lunch Break Food Pantry, accepted the contribution for her organization. (Courtesy of Count Basie Theatre.)

Charity at the Basie
A 2013 benefit hosted by the Count Basie Theatre Foundation raised more than $400,000 to help Hurricane Sandy survivors. Here, Linda Keenan (third from left), development director of the Food Bank of Monmouth and Ocean Counties, accepts the donation to her organization. Pictured from left to right are CBT and Food Bank board member Charles Woolston, CBT board member Peter Ardolino, Keenan, CBT board member and town councilman Ed Zipprich, and CBT board member Michael Parent. (Courtesy of Count Basie Theatre.)

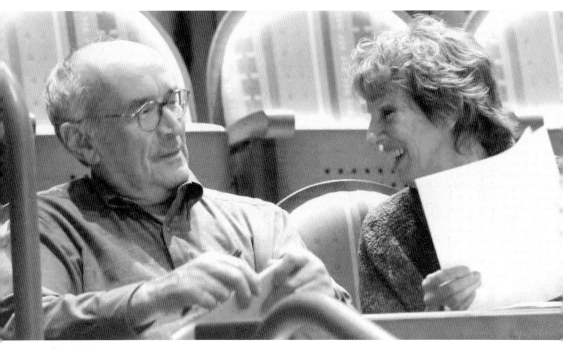

Robert and Joan Rechnitz (ABOVE AND OPPOSITE PAGE).
The first scene of the production that stars Robert and Joan Rechnitz is of their meeting at the University of Boulder where they both were attending a lecture by Buckminster Fuller. Back in those days, a person could smoke on campus, and Joan sat down next to the tall, handsome graduate student on the pretense of needing an ashtray.

It might easily work as a scene from a play debuting in the glamorous Two River Theater Company—and maybe, one day, it will. Word has it that Bob Rechnitz is working on his memoirs right now. For 33 years, Rechnitz was Professor Rechnitz, teaching English literature at Monmouth University. But he had always had an interest in directing plays, and when an opportunity arose for him to direct a play at Monmouth, he took it and ran, choosing *The Physicists*, a somewhat weighty play by Swiss author Friedrich Durrenmatt. Rechnitz selected the play, he said recently, because he figured that if it were terrible, the critics would blame the playwright rather than the novice director.

But it was not terrible. From there on, Rechnitz began his second career as a director, which would lead to his third act as the founder, with wife, Joan, of the Two River Theater, one of Red Bank's newest and brightest stars.

Founded in 1994, Two River Theater launched its opening season at Monmouth University with a production of *The Cocktail Hour*. They later moved to the Algonquin Theater in Manasquan while the Rechnitzes launched a fundraising effort and a real estate search that would eventually bring them to Red Bank. "Joan certainly felt that this was the place to be," said Rechnitz.

The Rechnitzes eventually purchased the former Blaisdell Lumber Company property on Bridge Avenue and began building their permanent space. Their decade-old theater is just across the street from the Galleria Building, a constellation of shops and restaurants that occupy the renovated factory building once owned by Sigmund Eisner.

Now under the artistic leadership of John Dias, the theater produces an eight-play season of classic and contemporary works and also features many readings, performances, and special events that involve the entire community in the theater. In 2012, the *Huffington Post* named the Two River Theater as one of the 10 best in the nation.

And it all began with a dream. "We were very fortunate that we could realize it," Rechnitz said. (Courtesy of Two River Theater Company.)

Dancing to the Waltz of Time

One of the things that Robert and Joan Rechnitz value most about their experience in creating the Two River Theater is watching young audiences from diverse backgrounds recognize the themes and dreams of drama and comedy that resonate in their own lives as well as on stage.

The theater regularly presents works by minority playwrights and hosts discussions with actors and playwrights where audiences can share their opinions and get the story behind the story. (Photograph by Danny Sanchez; courtesy of Two River Theater Company.)

Norman Seldin

Stormin' Norman Seldin—the other "kid from Red Bank"—started working in the family jewelry business almost before he could see over the counters. The experience gave Seldin a business education that came in handy a few years later.

Studying classical piano, he had learned about the blues from an African American man who worked in the family jewelry store, Horner Williams. He knew it was what he wanted to play. Soon, he was booking bands and playing professionally himself. "I was the youngest person to ever join the musicians union," he said. By the early 1960s, black groups were being heard on white radio, and Seldin began booking those groups in places where white kids would come to hear them perform. He was also playing the clubs in Asbury with his own band, Joyful Noyze. One night in a bar in Asbury, a "big black guy walked in to use the telephone." When he saw the band, he asked if they played every night, telling Seldin he played the sax. "Do you want to sit in?" Seldin asked. That was the night Clarence Clemons joined the band. He would remain part of Joyful Noyze until he left to join Bruce Springsteen's E Street. Having a black man in the band did not go over well with many of the club owners, Seldin recalled. At that time, black and white bands did not mix, and neither did their audiences. Fortunately, things were about to change. They refused to play clubs where black musicians were banned.

Seldin said that after the crowds stopped coming, the club owner often had a change of heart. In the era of the Beatles and Rolling Stones, Seldin started importing bands from Great Britain. He was also on the cutting edge with American acts. He remembers booking the Young Rascals for a local gig before they were famous. "That was the first time (Middletown native) Steven Van Zandt ever heard them," he notes.

By the time he was 18, Seldin had a thriving career as a booker, promoter, and bandleader. "I was 18 years old and driving a Jaguar," he said. "People hated me." In 2008, Seldin compiled a musical record of those early days of Jersey Shore rock'n'roll titled "Asbury Park Then and Now." The two-CD set is a popular seller around the world. "It all came out of Red Bank," says Seldin.

Joyful Noyze is pictured rocking the house at the old Lock, Stock and Barrel Restaurant in Fair Haven. Seldin is on the piano, with Clemons on saxophone. Billy Ryan is on guitar, Max Weinberg is on drums, and Gary Talent is playing the upright bass. (Courtesy of Norman Seldin.)

Seldin's Jewelers
Seldin's parents, Helen and Paul Seldin, were both classically trained musicians who opened a jewelry store in Red Bank in the 1950s. Seldin inherited the family passion for music and was further influenced by Horner Williams, an African American man who worked at the family jewelry store and introduced Seldin to black radio and the blues. Helen (left) and Paul (far right) are pictured during the ribbon-cutting of their Broad Street jewelry store. (Courtesy of Dorn's Classic Images.)

Tickling the Keys
As a teenager, Norman Seldin was traveling into New York every day to attend the Manhattan School of Music. His first gig after forming his band, the Naturals, at the age of 13 was at Trinity Episcopal Church on West Front Street in Red Bank. The Naturals are pictured performing in the Seldin family living room with Dave Kenny on drums, Alan Butler on guitar, an unidentified second guitarist, and Norman Seldin on piano. (Courtesy of Norman Seldin.)

Shaking it Up
Clarence Clemons stayed with Joyful Noyze until he made the switch to E Street in 1972. Tracks from an album Clemons made on Seldin's record label, Selsom Records, are included in the CD anthology "Asbury Park Then and Now." Pictured from left to right are Clemons, Norman Seldin, Barry Lynn, and Hal Hollander. (Courtesy of Norman Seldin.)

The British Invasion
By the late 1960s, Seldin was raking in cash as a promoter and bandleader. He remembers booking the Young Rascals at the Matawan Keyport Roller Dome, where Steven Van Zandt saw them live for the first time. Van Zandt, a Middletown native, recently nominated them to the Rock and Roll Hall of Fame. From left to right, Seldin, Barry Lynn, and Fred Billand pose with Seldin's Jaguar XKE coupe. (Courtesy of Norman Seldin.)

Still Making Noyze
Today, Norman's wife, Jamey, owns Seldin's Trinkets on West Front Street, which has a baby grand piano in the back that Seldin occasionally plays. After many years performing in Mississippi and Florida, he returned to Red Bank. His band is a regular at Zachary's in Long Branch and many other local venues. (Author's collection.)

Anderson's Music
The Anderson family has kept Red Bank tuned up for generations. John Beverly Anderson, known as Bev, sold televisions, pianos, and band instruments as well as LPs. His son Jack Anderson carried on the business as a record store, changing with the times as LPs gave way to CDs, videos, and DVDs, and the now legendary store, known as Jack's Music, endures. Famous bandleader Ted Weems (left) greets owner John Beverly Anderson during Weems's appearance at the music store on Broad Street in 1947. (Courtesy of Dorn's Classic Images.)

The Big Man

From 1981 to 1983, Clarence Clemons owned a rock club at 129 Monmouth Street called Big Man's West where many locals got to play with the legends of rock and roll. On the day this photograph was taken, he was in town while filming his first acting role as a trumpet player in Martin Scorsese's *New York, New York*. (Courtesy of Dorn's Classic Images.)

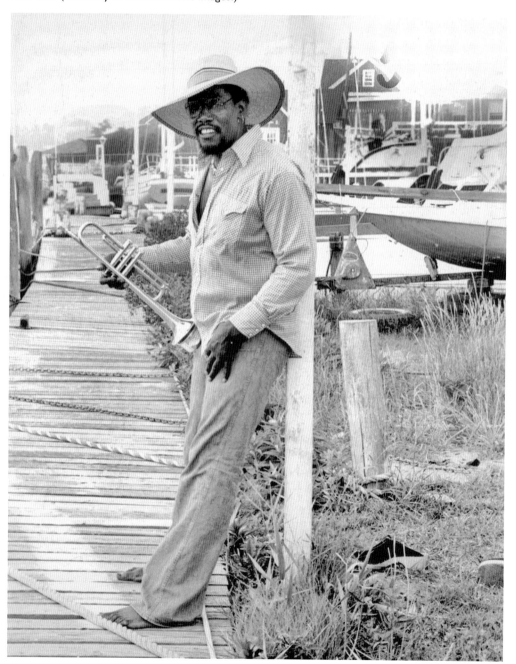

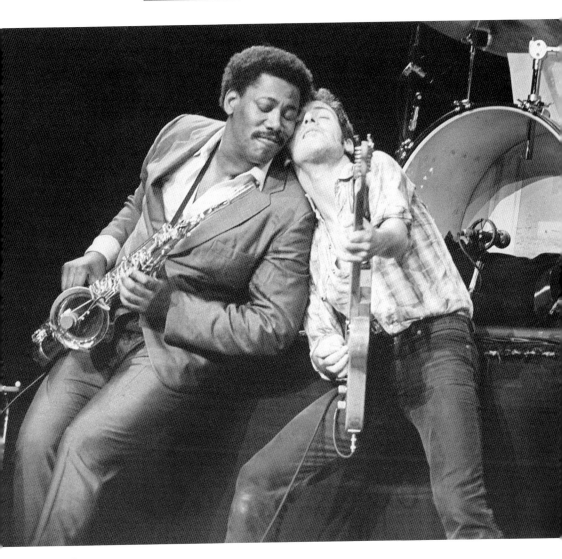

Soul Brothers
Rock-and-roll photographer Mark Weiss of Middletown captured this image of Clarence Clemons and Bruce Springsteen onstage at Madison Square Garden with the E Street Band. Clemons died in 2011 at the age of 69. Through the efforts of Red Bank resident and New Jersey senator Jennifer Beck, his birthday, January 11, is recognized in New Jersey as Clarence Clemons day. (Courtesy and copyright of Mark Weiss.)

Other Brothers

Photographer Mark Weiss's work has been featured on magazine covers and in centerfolds around the world. He worked with an eclectic assortment of heavy metal groups and rock-and-rollers that run the gamut from Steven Tyler to Jon Bon Jovi to Ozzy Osbourne. Weiss also works hard to support a number of charities that raise funds through exhibits and auctions of his iconic images.

He earned his first camera by mowing lawns for a summer when he was 14. Not longer after that, he started taking photographs at rock concerts and selling them on the street for a dollar each.

Weiss remembers, "My first recollection of Red Bank was around the mid-70s, in Jack's Music, flipping through the album racks looking at covers. I was 17 and I remember thinking how cool it would be to have one of my photos on the cover for the world to see. A decade later I would have photos I shot for album covers that sold millions of copies. . . . I shot the promotional and publicity photos of Bon Jovi in my pal Danny Sanchez's studio on Broad Street in 1986. In 2010, I had my first gallery show in Atlantic City, and after the show, I brought the photographs to Jack's Music to hang on their walls."

This photograph of Jon Bon Jovi and Mark Weiss, in their big-hair days, was taken during the "Slippery When Wet" session at the Count Basie Theatre in Red Bank. (Courtesy and copyright of Mark Weiss.)

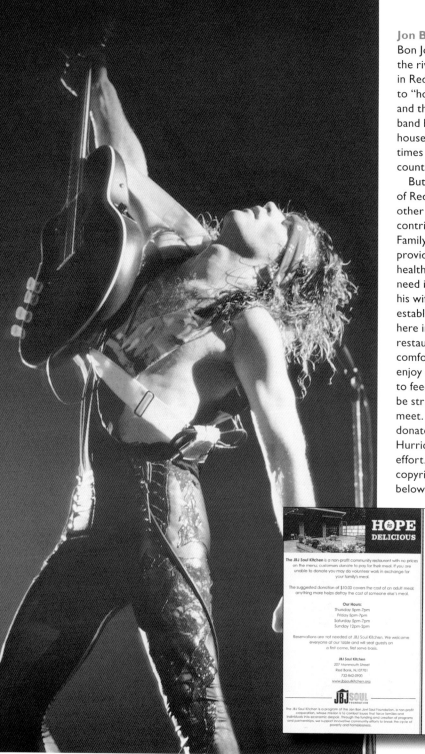

Jon Bon Jovi

Bon Jovi may live just across the river, but his presence in Red Bank entitles him to "home boy" status. He and the members of his band have burned down the house at the Basie more times than most people can count.

But Bon Jovi is a son of Red Bank in many other ways. He is a major contributor to the Parker Family Health Center, which provides free and low-cost health care to folks who need it, and Bon Jovi and his wife, Dorothea, also established the Soul Kitchen here in 2011, a chef-run restaurant where financially comfortable diners can enjoy dinner while helping to feed neighbors who may be struggling to make ends meet. Bon Jovi recently donated $1 million to the Hurricane Sandy relief effort. (Left, courtesy and copyright of Mark Weiss; below, author's collection.)

Bob Bandiera

One of the Jersey Shore's most admired figures on the music scene, Bob Bandiera is a rhythm guitarist with a lengthy musical resume. A longtime member of the Asbury Jukes, Bandiera is also a member of Jon Bon Jovi's band and a regular participant in Holiday Express, a band of professional musicians and other volunteers who bring a traveling holiday party to people in need during the Christmas season.

Throughout his career, Bandiera has always donated his talents to raise money for people in need. Several years ago, in 2003, Bandiera's son Robert was in need of specialized treatment at a neurological facility for a disorder he struggled with all his life. Bandiera decided to raise funds for his treatment through a concert he called "Hope." Just a few of his friends turned up, including Bon Jovi, Southside Johnny, Springsteen, and then vice president Al Gore and wife Tipper.

Since that time, Bandiera has volunteered his time as musical director and performer at many more Hope concerts, raising millions of dollars for charities and individuals who needed a helping hand. Pictured are, from left to right, Bob Bandiera, his son Robert Bandiera Jr., and band member Jim Celestino. (Courtesy of Bob Bandiera.)

Pat Guadagno

Self-professed saloon singer Pat Guadagno (center, at microphone) was playing at the Downtown Café 18 years ago when someone remarked that it was Bob Dylan's birthday. In honor of the occasion, Guadagno started playing Dylan songs, and a tradition was suddenly born. Each year ever since, on or around Dylan's birthday, Guadagno calls together the group of musicians who are known collectively as the Tired Horses (in tribute to another Bob Dylan song) for an all-Dylan performance.

After a few years, the event outgrew the Downtown Café, so Guadagno called the Two River Theater to inquire about renting their 400-seat theater for what had come to be called, BobFest. According to Guadagno, theater owners Bob and Joan Rechnitz said yes only because they thought it was going to be a gathering of men named Bob. Although the Rechnitzes say the story is apocryphal, it is nevertheless amusing, and they are happy to play along. But BobFest eventually outgrew the Two River Theater, too.

The show now takes place at the 1,400-seat Count Basie Theatre. A portion of ticket sales

are designated for the Anthony X. Guadagno Scholarship Fund, a charity Guadagno founded in memory of his younger brother, who was also a musician.. The scholarship helps to pay tuition for a deserving student at Berklee College of Music in Boston, Tony's alma mater.

When he is not playing Dylan, Guadagno's repertoire ranges across genres, regions, decades, and continents. His rendition of the Warren Zevon song "Don't Let Us Get Sick" was featured on the television series *Californication*. He has several CDs to his credit, including his most recent, "New Jersey Material," featuring his interpretations of songs New Jersey songwriters.

Members of the Tired Horses include Joe D'Angelo, drums; Andy McDonough, piano, keyboards, and accordion; Marc Muller, pedal steel, keyboard, and accordion; Rob Papparozi, harmonica; Phil Rizzo, bass guitar and vocals; Steve Delopoulus, guitar and vocals; Jeff Levine, Hammond B3 organ; Mary McCrink, vocals; Rich Oddo, electric guitar and vocals; Steve Reilly, guitar and vocals; and Yuri Turchin, electric violin. (Courtesy of John Posada.)

Danny Sanchez

Photographer Danny Sanchez often does work for national agencies and advertisers in his studio on Bridge Avenue in Red Bank. But in this area, Sanchez is best known for the way the insignificant details fall away when he looks at a subject through his camera lens. Danny Sanchez is a master at capturing people in the act of being themselves.

That magic touch can be seen in his portraits that appear in this book, including those of Bob and Joan Rechnitz, Claudia Ansorge, Doris Kulman, and T.J. McMahon.

In 2010, Sanchez was honored by the Monmouth County Arts Council, which presented a "Forty Faces" of Monmouth exhibit featuring Sanchez's unforgettable portraits of the people who live, work, and play in Monmouth County. (Courtesy of Danny Sanchez.)

James Avati

Renowned as "the Rembrandt of Paperbacks," artist and illustrator James Avati lived most of his adult life in Red Bank and often used fellow Red Bank residents as models for his illustrations.

Avati's illustrations appeared on thousands of book covers including classics like J.D. Salinger's *Catcher in the Rye* (The New American Library, 1953); James Michener's *Return to Paradise* (Fawcett Books, 1984); and Richard Wright's *Black Boy* (Harper and Brothers, 1945). (Courtesy of Dorn's Classic Images.)

Tim McLoone and Holiday Express

Each year on the day after Thanksgiving, Tim McLoone and his Holiday Express band take over Broad Street for a free holiday concert that brings thousands of people into town.

Holiday Express (which includes Red Bank's very own "Rockettes" from the Kathryn Barnett School of Dance) travels to homeless shelters, psychiatric facilities, rehabilitation units, food pantries, veterans hospitals, and long-term care facilities, bringing food, gifts, games, crafts, fun, and live music performed by people who, in their professional lives, often share the stage with some of the biggest names in the business.

Most events are private for the special audiences the organization serves. But every year, Holiday Express presents a few public performances, too, and the Red Bank Tree and Town Lighting has been on its calendar from the start. As Tim McLoone says, it is one way of saying thanks to all of the people who quietly support the organization throughout the year. (Above, author's collection; below, courtesy of Kathryn Barnett School of Dance.)

CHAPTER FIVE

Only One Red Bank

Early on summer mornings, the history of Red Bank still rides the river, as lone canoeists and kayakers paddle its placid waters, as young sailors learn the ropes on their vessels, and members of area rowing clubs glide gracefully in harmony across the Navesink. Today, cars and trains travel over the bridges that link Red Bank with other faraway places.

It is a cosmopolitan place; a place where the descendants of the signers of the Monmouth Patent wait for their morning coffee in line behind an immigrant from Belarus or a rock star recently off the road. Always a crossroads, if not a melting pot, Red Bank has grown into a town where most folks can find a welcome. And more than 100 years after it officially became a borough in 1908, Red Bank remains a place where people dream big and travel far.

As it was 100 years ago, the Navesink River is busy in the summer with paddles and sails. Only in winter does the river return to its own deep thoughts, undisturbed by the passage of time. But when a solid freeze settles in, local iceboaters take off from work, and out-of-town iceboaters begin to arrive from as far away as Canada, ready to compete in the trophy race that is only held at the whim of mother nature. When a deep freeze occurs, the scene on the river returns to the way it must have looked 125 years ago. Many of the iceboats raced today were built in the late 1800s, among them the *Rocket*, built in 1888.

Much has changed here; much remains the same. Today, the "manly art" of rowing is considered womanly, too. The Elks, the Rotary, the Lions, and the Y are open to women and people of color. Unlike the 1920s, when the Ku Klux Klan felt free to parade down Broad Street, the town of Red Bank strives to be an inclusive community, where people who differ make an effort to get along. And as the hands of the lollipop clock installed by Leon De La Reusille in 1902 turn from hour to hour, history is being made. This is Red Bank, on the Navesink River, in 2014.

Claudia Ansorge

About the time that elected officials and retailers in the borough of Red Bank were devising a strategy to rescue Red Bank from the fate of other struggling small towns around the nation, more help arrived in the form of a dream being realized by Red Bank resident Claudia Ansorge.

Formerly a partner in a successful ad agency, Ansorge had always wanted to own a newspaper. The *Red Bank Register* had ceased publication, and there was no other newspaper focused solely on Red Bank and the towns around the peninsula. So she set about creating one. She called her fledgling publication the *Two River Times*, a named that had occurred to her one day when she glanced at a map of the Navesink and Shrewsbury Rivers.

With the words "two river," Ansorge successfully defined a region that had never before enjoyed a shared identity. Today, there are many businesses that identify themselves with the two-word phrase she invented. The first issue debuted in September 1990 with the tag line "The newspaper that's all about us." By turns literary, artistic, and neighborly, the paper celebrated the beauties of the Navesink River and the life that surrounded it in a way that had never been done before.

Though it was a creative success, it had been born during a recession, and the paper was soon struggling financially. Early in 1991, Ansorge decided to find eight investors willing to share in her dream. Among those Ansorge approached was celebrity journalist Geraldo Rivera, who had recently moved to Middletown. Instead of taking a small share of the paper, however, Rivera offered to buy a 75-percent share, and the paper was off and running.

Over the next 15 years, the *Two River Times* won dozens of awards for reporting, writing, and illustration and helped to raise Red Bank's profile as a community on the rise.

Ansorge also involved herself in the renaissance of Red Bank through her participation on the board of Red Bank River Center and in many other community organizations. She sold her interest in the paper in the mid-1990s but remained involved in Red Bank as the publisher of *Red Bank Red Hot* magazine and numerous other publications in Red Bank and around the state. Rivera sold his interest in the paper when he left the area in 2004. (Courtesy of Danny Sanchez.)

Geraldo Comes to Red Bank

Celebrity journalist Geraldo Rivera was a recent arrival in the area when Claudia Ansorge invited him to become an investor in the *Two River Times*. Instead, Rivera became majority owner. During his 13 years at TRT, the paper earned national attention for its environmental advocacy and investigative journalism and for Joan Lucky's coverage of the social scene via its People Pages. Rivera sold the paper to Wall Street executive Michael Gooch in 2004. (Author's collection.)

Sharon Rivera

Geraldo Rivera's sister Sharon Rivera, a former advertising representative and chief operating officer of the *TRT*, was honored by the borough in 1996 as a Red Bank Ambassador. She is pictured in this 1998 photograph at an appearance by one of her heroines, civil rights leader Coretta Scott King (seated, center), in Long Branch. From left to right are an unidentified King staffer, author Eileen Moon, Sharon Rivera, and Robin Fitzmaurice of Two River Community Bank in Red Bank. (Author's collection.)

The World Did Not End

With its towering trees, green lawns, and welcoming, turn-of-the-century front porches, South Street is the picture of an old-fashioned, American neighborhood.

It seems an unlikely place for the founder of an end-of-the-world religion—a self-described, official messenger from God—to have been born and raised, but it is exactly where Elizabeth Clare Prophet, born Elizabeth Clare Wulf, spent her childhood. As much a child of Red Bank as anyone who called it home, Prophet would leave her life here far behind her, eventually becoming the leader of the Official Church Universal and Triumphant, a new-age religion that told believers that the world was on the verge of nuclear holocaust. The church had established an elaborate plan for the survival of God's chosen, constructing well-equipped bunkers underground on lands they owned in Montana.

From her earliest years, Prophet seemed to be in search of spiritual refuge. After sampling the religious offerings in Red Bank as a child, Prophet settled on the Christian Science church. Born in Red Bank in 1939, Prophet enjoyed the pleasures of a small-town childhood—walking to school each day, coming home for lunch, painting the downtown store windows for the annual Halloween contest, and playing clarinet in the high school band.

But there were struggles in Prophet's life that troubled and challenged her long into adulthood. Her father's temper when he was drinking made home life difficult. Prophet also was an epileptic and suffered from what was known as absence seizures. Despite that disability, she was a gifted student. After spending a year in Switzerland studying French, she returned to Red Bank High School, graduating second in her class.

After two years at Antioch College in Ohio, she transferred to Boston University, where she earned a degree in political science. It was in Boston that Prophet met the man who would become her husband, Mark Prophet, who claimed to relay messages from the archangel Michael. Under her husband's tutelage, Prophet began to relay messages from the "Ascended Masters," heavenly beings who included Jesus Christ and Buddha.

In the late 1980s, believers began preparing for Armageddon in the form of a nuclear attack, stocking supplies in underground bunkers on a 12,000-acre property the church had purchased in Montana. By 1998, Prophet's failing health forced her to retire from leadership in the church. She died in 2009 after suffering from Alzheimer's for several years. (Courtesy of Erin Prophet.)

Sharon Lee

On a rainy spring Saturday, Sharon Lee was busy tending her plants and fighting the weeds in the yard of the home she had owned on the west side of Red Bank for more than 25 years. She owes the fact that she's a Red Bank native to her grandmother, who moved here from Farmville, Virginia, with her 14 children in the 1930s. Her husband stayed behind because he had a good job as a janitor at Longwood College. The move was inspired by her grandparents' desire to find a safer place to raise their children. In the South of the 1930s, riots, lynchings, and beatings of African Americans were all too common.

The shore area offered the opportunity for work in the resorts and estates of wealthy white people. Lee's grandmother found work as a domestic, and the family settled on the west side of Red Bank, then a mixed neighborhood of black, Italian, and Jewish immigrants. An outstanding student, Lee's mother was hired first as a cook at Fort Monmouth. She soon qualified for a different job—teaching basic electronics to black soldiers in the still-segregated Army. There, she encountered a cute soldier from Louisiana named Raymond Lee, and the two were married.

Though they traveled with her father during his military career—Lee spent six years in Germany as a child—Red Bank was home. "I couldn't walk three steps without bumping into a cousin," she laughs. But even in Red Bank, there was a racial divide. Lee remembers when she was hired as a bank teller at the First Merchants Bank on Broad Street as a teenager in the early 1970s. She was only the third person of color to work on Broad Street. "My parents would sit across the street and look at me through the window, to see me working in an office: my mother in her maid's uniform and my father in his mechanic's uniform."

Lee went on to study library science at Johnson and Wales College in Providence, embarking on a career in the tech industry at companies like Bellcore and Telcordia. She served two terms as a Red Bank councilwoman and is one of only three African Americans to ever serve as an elected official in the history of Red Bank. "When you are a politician, you work for everyone," she says. (Author's collection.)

Stanley Sickels

Borough administrator Stanley Sickels is a fourth-generation Red Bank resident whose family history is almost inseparable from the history of Red Bank. He and his wife, Donna, a former borough employee, have raised their three children, Jessica, Samantha, and Garrett, in one of the two houses on McLaren Street that the Sickels family has owned for generations.

Sickels holds three jobs with the borough: fire marshal, construction code official, and borough administrator. He began preparing for his role as fire marshal as a small boy when he eschewed other forms of boyhood entertainment to roam around the neighborhood with his fire wagon and hose, ready to leap into action should he encounter a smoldering pile of leaves or carelessly dropped cigarette.

"I got the bug as a young kid," he recalled recently. "The fire horns used to wake me up and my mother used to rock me back to sleep singing songs about fire trucks." And when the family went to the diner on Monmouth Street, he got to visit the firehouse where one of the firefighters presented him with an old helmet. "I used to run around the neighborhood with it. I still have it," he said. His father made him a wooden fire wagon, which he stocked with a six foot scaffolding ladder and a length of garden hose. "When people would burn their leaves, I would show up with my wagon and put the fire out," Sickels recalled recently.

Being a firefighter was all Sickels ever wanted to do. When he turned 18 in 1973, he submitted his application to join the Red Bank Fire Department at its very next meeting.

Over the years, he has taken advantage of every course or training opportunity available and has become one of the most respected professionals in his field. He has also fought thousands of fires, some of them fatal and, sadly, preventable. Sickels has a reputation as a tough cookie when it comes to requiring that home and business owners thoroughly comply with construction and fire codes.

"This is not like a speeding ticket," says Sickels. "If there's a code violation, if your fire sprays are not working, if your fire alarm isn't monitored, you're going to die of smoke inhalation. I tell you what you need to hear, not necessarily what you want to hear." (Courtesy of Stanley Sickels.)

A Day on the River
The Sickels family is picnicking at Spermaceti Cove. Pictured are Charles E. Sickels (Stanley's great-grandfather, with beard); Elizabeth Fairbrother Sickels (Stanley's grandfather Ralph B. Sickels's wife, with baby Donald Sickels, Stanley's uncle); Stanley's great-aunt Helen (sitting), wife of Guy Sickels (with pipe); Stanley's aunt Percis Sickels Boyd (standing), wife of Charles Boyd (in tent); and Helen and Guy Sickels's children. (Courtesy of Stanley Sickels.)

Runner-philosopher George Sheehan, MD

Among the most legendary of Red Bank locals is Dr. George Sheehan, a cardiologist at Riverview Medical Center, who, in the middle of his life, returned to a sport he had loved in college and, in doing so, helped to fuel an international running and fitness movement that has changed thousands of lives.

One of 14 children, Sheehan was the father of 12, many of whom followed their father onto the open road. "Every mile I run is my first," wrote Sheehan in his best-selling book, *Running and Being* (Simon and Shuster, 1978). "Every hour on the roads a new beginning. Every day I put on my running clothes, I am born again."

For many years, he wrote a column for the *Daily Register*, combining running advice with his reflections on the ideas of the great philosophers. He also wrote a column for *Runner's World* magazine that was among their most popular features.

"We were not created to be spectators," Sheehan wrote. "Not made to be onlookers. Not born to be bystanders . . . Life must be lived. Acted out. The play we are in is our own."

Pictured at the bottom of the opposite page are young Michael Kroon and Dr. Sheehan at the front left with young Steve Kroon behind them. Mrs. Kroon (Rick Kroon's mother) stands with her hand on the railing with Mary Jane Sheehan, Ann (Sheehan) Andors, Molly (Kroon) Jennings, Sarah (Kroon) Chiles, Maureen Sheehan (Tim Sheehan's wife), Mary Jane (Sheehan) Kroon, and young Andrew Kroon standing from left to right in the back. David Kroon is standing in the center with Stephen Sheehan next to him; in front of them stand Rick Kroon on the left and George Sheehan, Jr. (All, courtesy of the Sheehan family.)

Sal's Tavern

"If a man takes a drink, that's his business. If a woman smokes, that's her business. Our business is to please you. You can be double and triple sure." Those are the words on the menus at Sal's Tavern.

For some 60 years or so, Sal's Tavern on Shrewsbury Avenue was the spot where newspaper folks, politicians, mailman, attorneys, and truck drivers gathered for a beer at the long, mahogany bar—a bar that having once been in the Sheridan Hotel down on Front Street was historic in its own right.

Dinner typically began with a tray of pickled peppers and tomatoes, followed by fresh Italian bread, then bowls of pasta fagioli and plates of spaghetti with Sal's special meatballs and sauce. It was unpretentious food for unpretentious people.

Italian immigrant Salvatore Vaiti opened his restaurant during the Great Depression, and he celebrates its anniversary every year with a "Roll Back the Clock" night during which it offered menu items at 1933 prices; lines formed around the block for the event.

Former mayor and state Supreme Court Justice Daniel O'Hern was a Sal's aficionado who was known to apply the "Sal's Tavern test" to any proposal he felt warranted careful consideration: if the guys down at Sal's would not buy it, then O'Hern believed it was not worth pursuing.

Information-age pioneer Robert Lucky, inventor of the adaptive equalizer, was a Sal's regular, as well. Lucky and two other Bell Labs engineers wrote their book, *Principles of Data Communication*, during their weekly get-togethers at Sal's.

After Sal's death at age 83 in 1981, his sons Dominic and Lou (pictured behind the bar), who also owned the Olde Union House, continued the business until the mid-1990s, when they decided to retire. (All, courtesy of Dorn's Classic Images.)

George Bowden

George Bowden's longtime interest in history made him a natural for appointment as chair of the Historic Preservation Commission in Red Bank.

Now, chairman emeritus, Bowden has been a resident of Red Bank for more than 30 years. He became involved in the effort to preserve some of Red Bank's historic buildings because it troubled him to see them fall to the wrecking ball, often replaced by unlovely architecture.

Bowden considers two of the most regrettable losses to be the demolition of the Morford house, which was believed to have been among the oldest in Red Bank, and the demolition of the Rullman house, both on Front Street. But there have been successes as well. For example, Washington Street, which has many stately Victorians built by schooner captains and ship's carpenters, is now recognized as an official historic district. And the once-endangered Century House, which predates the Civil War, was moved across town to become part of the Red Bank Charter School. It was once the home of "Black Bill" Conover, whose fervent support for abolition and the end of slavery gave him his nickname. (Courtesy of George Bowden.)

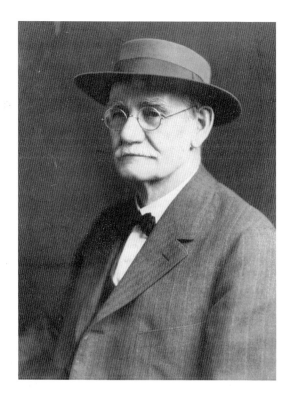

John H. Cook

John H. Cook and partner Henry Clay founded the *Red Bank Register* in 1878. For Cook, the politically independent weekly would be a life's work. Clay would leave after about a year.

From the beginning, the *Red Bank Register* was a serious weekly that was not above taking potshots at its nearest competitor, the *Red Bank Standard*. Virtually everything that happened in the town and its surrounding communities was the *Register*'s business, and in recording the everyday life of the towns it covered, the newspaper left a precious legacy. In 1928, just two years before his death, Cook sold a controlling interest in the paper to Irving Brown, who managed the paper until his death in 1959.

That same year, the *Register* began to publish Monday through Friday, and in 1965, the paper was sold to the Toledo Blade. Arthur Z. Kamin, who started at the *Register* as a reporter in 1956, was promoted to editor of the paper and, later, became president and publisher.

In the years that followed, the *Register* covered a rapidly changing world. Civil rights, women's rights, war, and hippies were captured in its pages as the 1960s, 1970s, and 1980s unfolded. Doris Kulman's column "The Sexes," which pondered the unreasonable inequalities between the sexes with humor and intelligence, made Kulman a statewide star as it helped to change attitudes and champion the cause of equal rights.

Dr. George Sheehan, the runner-philosopher physician who became famous worldwide, wrote a weekly column that he tapped out on his old manual typewriter in the *Register*'s newsroom. Well into the 1970s, the paper was a thriving operation. But things began to chance in the 1980s, when the paper was sold to Capital Cities, a major communications firm, and veterans on the staff were fired. It was the start of a rapid descent for the formerly beloved newspaper. By 1991, the once-great paper was out of business.

"The *Register*, with its first-rate reporting staff, did a thorough job of covering the county and the municipalities it served," former editor Art Kamin said recently. "The paper often was judged one of the best in the state. Through its significant editorials and dynamic opinion pages, the *Register* helped to enhance the quality of life in the county." (Courtesy of Red Bank Public Library.)

Arthur Z. Kamin

Beginning as a stringer in the 1950s when he was stationed at Fort Monmouth, Arthur Z. Kamin of Fair Haven rose to become president and publisher of the *Daily* and *Sunday Register* during some of the most tumultuous times in the nation's history. Starting in the early 1950s when the *Register* was a weekly, Kamin guided the paper through the long evolution of attitudes and morals that included the civil rights movement, the ecumenical religious movement, the war in Vietnam, and the Watergate controversy.

Kamin, who also served as chair of the Rugers University Board of Trustees, where he had been editor in chief of the *Targum* during his undergraduate years, was a mentor and role model to generations of young reporters. Kamin is pictured with young reporter Mark Magyar, now the cofounder and director of the Independent Center at Rutgers University.

Kamin and his wife, Virginia, a teacher in the Fair Haven school system, raised two children. Their son Blair Kamin won a Pulitzer Prize for architecture and recently returned to his job at the *Chicago Tribune* after completing a Niemann Fellowship at Harvard University. Daughter Brooke Kamin Rappaport is curator of Madison Square Park in New York City. (Courtesy of Arthur Z. Kamin.)

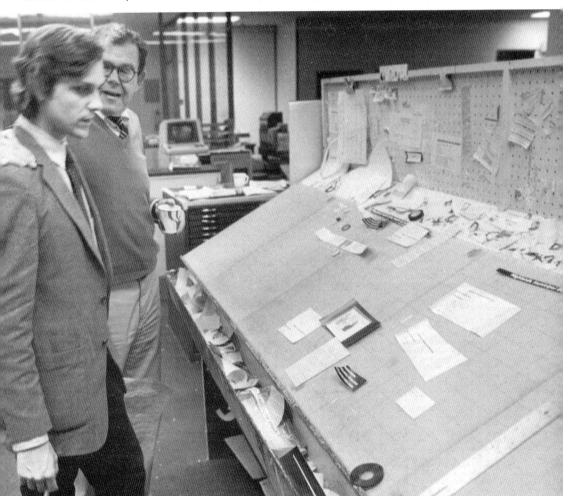

Doris Kulman

Doris Kulman Raffolovich never lived in Red Bank, but she spent the great majority of her working life here as a reporter, columnist, and editorial page editor for the *Red Bank Register* and several other publications.

A careful and dedicated reporter, Kulman won numerous journalism awards during a career in which she covered civil rights, antiwar protests, scandals, controversies, and political intrigues. A Paterson native, Kulman's career choice was inspired by her passion for social justice and her lifelong belief that words could change the world.

In the 1970s, Kulman (the name she used professionally) began writing a column called "The Sexes," which explored the issues then making headlines as the women's movement gathered strength. Her columns often focused on issues that were arising locally, such as the news that women were banned from membership in a local first-aid squad on the presumption that women could not stand the sight of blood, or a case in which a woman had been turned down for a janitorial job on the grounds that wielding a mop would be too strenuous for a woman.

Kulman's greatest weapon was the wit with which she approached many of the issues that were undergoing heated discussion at the time. To her newsroom colleagues, she was a mentor, a friend, and an inspiration who always did her homework. She chose the following Edna St. Vincent Millay poem, paying tribute to an early feminist, as her memorial tribute: "And make immortal my adventurous will./ Even now the silk is tugging at the staff: / Take up the song; forget the epitaph."

Kulman's writings are archived in the Mabel Douglass Library on the Rutgers University campus. (Courtesy of Danny Sanchez.)

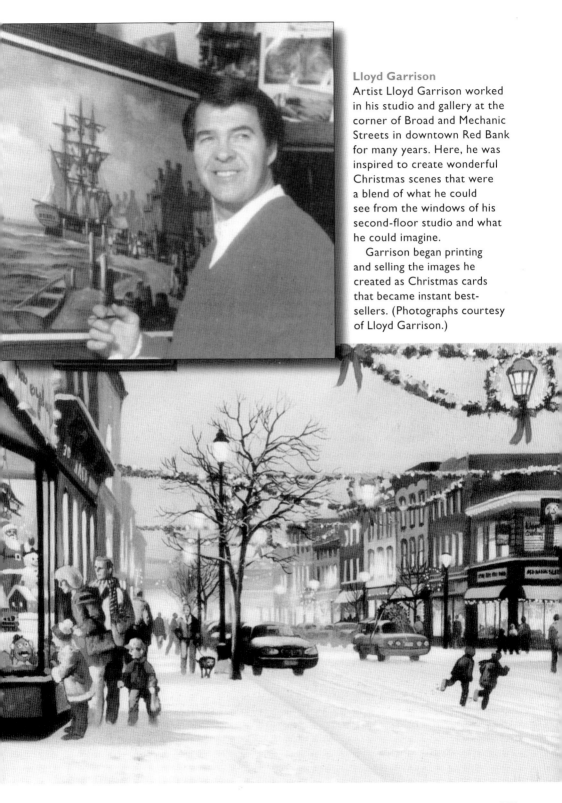

Lloyd Garrison
Artist Lloyd Garrison worked in his studio and gallery at the corner of Broad and Mechanic Streets in downtown Red Bank for many years. Here, he was inspired to create wonderful Christmas scenes that were a blend of what he could see from the windows of his second-floor studio and what he could imagine.

Garrison began printing and selling the images he created as Christmas cards that became instant best-sellers. (Photographs courtesy of Lloyd Garrison.)

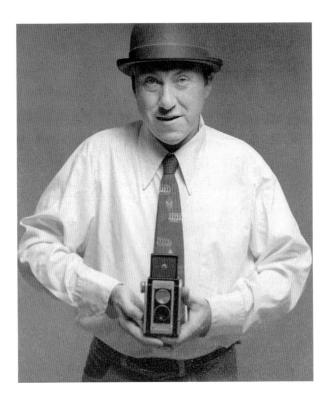

T.J. McMahon

If anyone deserves the title of legendary local, it is T.J. McMahon. A Fair Haven native, McMahon worked for many years as a dishwasher at the Dublin House Pub in Red Bank.

Always friendly and always polite, McMahon had a wicked sense of humor and an Irish accent—despite the fact he had been born and raised on this side of the Atlantic. He was the only child of Irish immigrants whose social lives revolved around other Irish immigrants. Like McMahon's parents, many of those immigrants were drawn here by the opportunities for work on the affluent estates of Rumson.

Although some mistook McMahon as simply eccentric, there was much more to this kind man than met the eye. He had a memory that allowed him to immediately called up fact from the most distant past on a moment's notice—with complete accuracy.

A graduate of Red Bank Catholic High School, he earned a master's degree in history at Monmouth University, had an extensive collection of historical archives, and a long career of speaking and writing about historical topics related to the two rivers and beyond. While studying for his master's, he worked as an electrician's helper and as a carpenter. He also taught history at Rutgers University.

He was a favorite at the Dublin House, where his other job was writing the Dublin House newsletter, containing interesting historical information, like the fact that the ghost of a former owner often patrolled the upstairs rooms of the Victorian home that became the Dublin House.

In 2006, the Borough of Red Bank paid tribute to McMahon in honor of his many contributions to the community as a historian and advocate for historical preservation, and when it came to fighting historic preservation battles, he was a force to be reckoned with.

"I admired his tenacity to stand up to high-powered lawyers," said then councilman John Curley, now a Republican freeholder. "He stood up and spoke the facts. He was the right and left hand of the Red Bank Historic Preservation Commission."

After McMahon died in 2005 at the age of 64, the Dublin House dedicated its dining room in his memory. If McMahon were to haunt any place in Red Bank, it would likely be the Dublin House, as it is full of interesting conversation, interesting folk—and of course, another ghost to keep him company. (Courtesy of Danny Sanchez.)

Mayor Pasquale Menna

Red Bank mayor Pasquale "Pat" Menna could not speak English when he arrived in Red Bank at the age of nine. The mayor was born just outside Naples, Italy, immigrating to the New World with his family at the age of seven.

The Mennas first settled in Montreal, where his mother had relatives, but later relocated to Red Bank to be near his father's family. The native Italian speaker learned French during the two years he lived in Montreal, but the move to Red Bank meant it was time to tackle a third language. Menna, his siblings, and parents moved in with his aunt and uncle and his aunt's parents in a house on Bridge Avenue. His father found work in a factory while his mother worked as a seamstress.

Menna's uncle Charlie and aunt Rose owned the West Bergen market, a neighborhood store where everyone got groceries, whether they happened to have money that day or not. "He was never stiffed by anybody," Menna said.

Menna started third grade at Oakland Street School, where a few caring teachers like Lillian Jordan and Tina DeFalco helped ease his transition. "Mrs. DeFalco was the icon for a caring, teacher," Menna said. "She made sure that the other kids didn't pick on me," Menna recalled. She also stayed after school to work with him on his English. "Nobody paid her to do it."

Menna also became an altar boy at St. Anthony's, a mostly Italian Catholic Church on Chestnut Street, where the pastor, Monsignor Salvatore Di Lorenzo, encouraged him to get an education. "He was a very traditional, brilliant yet humble man," Menna said. "He helped me understand the importance of learning." When Monsignor Di Lorenzo died, the priest willed the Bible from which he had prayed at his ordination to his former altar boy.

And the boy who could not speak English is now an attorney and the multilingual mayor of a town whose diversity he considers one of its greatest strengths. (Photograph by Joan La Banca.)

Edward J. McKenna Jr.

Edward J. McKenna Jr. was mayor of Red Bank longer than any other mayor in the town's history. Elected in 1990, the always outspoken and often controversial McKenna opted to hang up his hat in 2006 after 16 years in office in order to care for his wife, Christine, who was battling cancer. She died in 2009 at the age of 58. His decision to run for mayor had everything to do with a remark a friend of his made while they were shopping at a downtown clothing store. When someone asked the friend where he lived, he named another town nearby, even though he lived in Red Bank. When McKenna asked him why he had lied, the friend responded, "I'm ashamed to say I live here." McKenna decided then that he would do whatever it took to turn the fortunes of Red Bank around. The town was enduring a punishing recession. A major developer had gone bankrupt, leaving dozens of foreclosed properties around town. The retail vacancy rate was 35 percent.

McKenna grew up here. His father, also Edward McKenna, was a dentist whose office was located in the McKennas' house on Reckless Place. They had eight kids in the family, three bedrooms, and one bathroom. All of the kids went to Catholic school, and all of them graduated from college, some with advanced degrees.

McKenna earned a law degree at Georgetown University and clerked for two judges who were also former mayors of Red Bank, Daniel O'Hern and Benedict Nicosia. They became his mentors.

By the time he was elected mayor, McKenna had served as a councilman for several years and was well aware of the obstacles that faced the town. But Kerry Zukus, then a business owner in town, had heard of a state program designed to help struggling downtowns reinvent themselves.

With McKenna in the lead and the support of key stakeholders like Lawrence Roberts, a regional partner for Merrill Lynch; James P. Barry and Kevork Hovnanian, owners of the borough's two luxury hotels; and developers Jay Herman, John Bowers, and Mike Sullivan, the borough established a special improvement district to renovate, manage, and promote the downtown. Though never without controversy, the effort succeeded. By the mid-1990s, Red Bank was a national model for downtown revitalization.

"We got everyone to buy in," McKenna said. "That was a huge part of our success. I still feel incredibly lucky that people are still grateful for what we did." In 2012, *Smithsonian* magazine named Red Bank one of the 10 best small towns in America. (Photograph by Joan LaBanca.)

Daniel Joseph O'Hern

Former associate chief justice of the New Jersey Supreme Court Daniel Joseph O'Hern was a Red Bank native who never forgot his roots.

While he and his wife, Barbara, lived in Little Silver at the time of his death in 2009, but he asked her to be sure that his obituary said he was "of Red Bank" rather than Little Silver.

Born in Red Bank in 1930, O'Hern commuted to Regis High School in his teens and then earned a degree at Fordham College in 1951. He served four years in the Navy before entering law school, graduating from Harvard Law School in 1957. He clerked for US Supreme Court Justice William Brennan after his graduation and then began the practice of law in Red Bank.

In 1962, O'Hern was elected to the borough council in Red Bank and, later, served as mayor. His philosophy about public service was a simple one—"What people want is their streets cleaned, the snow plowed, and things like that," he advised aspiring politicians. In an interview he did for the archives of the Monmouth County Library, O'Hern talked about his love for Red Bank: "People want to live here because they want to share this experience . . . it is the way people want to live . . . they want to be connected to the community."

In 1978, Gov. Brendan T. Byrne appointed O'Hern to serve as the commissioner of the New Jersey Department of Environmental Protection, where he served from May 1978 until July 16, 1979. He then served as the governor's chief counsel until he was appointed to the New Jersey State Supreme Court in 1981, where he served for 19 years. O'Hern died on April 1, 2009, at the age of 78. During his funeral service, his children shared a eulogy that read in part, "'We are forever indebted to him for instilling in us the values that guided him so well throughout his life, above all that it is more important to be concerned about your character that your reputation. For if you are a man of character, your reputation will follow.'"

O'Hern's son, also Daniel, is now the borough attorney for Red Bank. (Courtesy of Byrne Archives, Rutger's University, Eagleton Governor's Institute.)

Coach Jack Rafter

Jack Rafter had a quote he liked to share with the students he coached at Red Bank Catholic (RBC) High School. Actually, he had a few, but among his favorites was this quote by World War II legend Adm. Bill Halsey: "There are no great men. Just great challenges which ordinary men, out of necessity, are forced by circumstance to meet."

It was something he wanted them to keep in mind as they ran track and cross-country—as they ran the race of life. Rafter, who taught history and coached sports at RBC for 45 years, died in 2011 at the age of 79. But the lessons he taught generations of RBC students have lives of their own.

When Rafter came to RBC in 1962, the school had no boys' track team. They had no girls' track team, either, but in the 1960s, the idea of girls' track was laughable—literally. When Rafter proposed the idea, he was told that girls could not run. What is more, the school had no funds to waste on the idea. Rafter persevered.

The boys' track team he inaugurated became a legend in its own right. In 1988, Rafter was honored on the floor of the US House of Representatives for having the most cross-country victories of any track team in the nation. By 1975, when he retired from coaching, RBC's record for girls' cross-country was 9-0, and the record for girls' track was 101-1.

Joe Freeman of Tinton Falls started running cross-country with Jack Rafter in 1965. The lessons he learned were life long. Today, he is the race director for a memorial run in his former coach's honor that takes place each August in Tinton Falls. "'Never give up,' that was what he believed," Freeman said. "He was a fan of the underdog and he appreciated the effort more than the result; the improvement of the individual as a member of the team."

Inducted into the New Jersey Sports Hall of Fame and the RBC Hall of Fame, Rafter is also revered nationally as the father of girls' track. (All, courtesy of the Rafter family.)

The Dorn Family of Photographers

In Red Bank, the Dorn family name means photography in the same way that Campbell's means soup. Three generations of the Dorn family filmed and preserved the photographic history of Red Bank in the 20th century.

Daniel Whitfield Dorn (right) established Dorn's Photography on Wallace Street in 1937. He inherited the family penchant for photography from his father, Daniel DuBouchet Dorn, who made his own career as a filmmaker and photographer in the early 20th century.

An unrepentant adventurer, Dan W. thought nothing of dangling out of an airplane with a camera in his hand. According to one legend, he once rode all the way to Sea Bright on his Indian motorcycle—standing up. A beloved, legendary local, Dan W. died in 2005 at the age of 94.

Under the ownership of son Dan Jr., Dorn's Photo Shop remained in business until 2005, when the revolution in digital photography signaled the end of a 70-year-old era. Dan W.'s daughter Kathy Dorn Severini and her husband, George Severini (below), are the proprietors of Dorn's Classic Images (Dornsclassicimages.com), which specializes in historic photographs. (Both, courtesy of the Dorn-Severini family.)

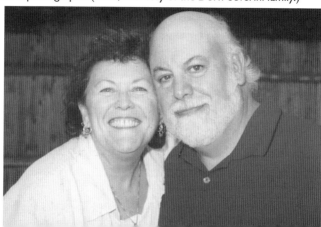

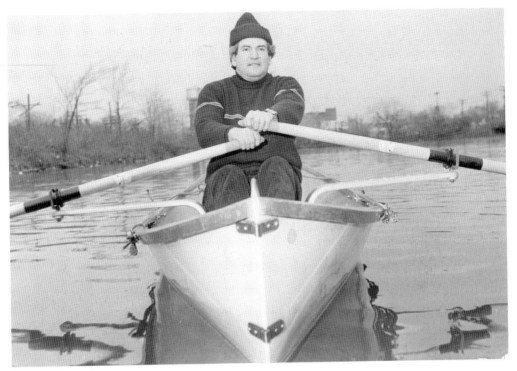

Rowing on the River

Fair Haven resident Charles Gross (pictured) founded the Navesink River Rowing Club (NRR) in 1983. Club member Kay Vilardi spearheaded NRR's move to Red Bank in the 1990s. Today, thanks to a grassroots group of river enthusiasts, rowers, kayakers, and canoeists enjoy access to the river at Maple Cove, a pocket park at the foot of Maple Avenue. Each year when the weather warms, NRR hosts regular open houses there to introduce children and adults to the pleasures of the river. (Courtesy of Navesink River Rowing.)

The Virtual Village

In 2006, husband-and-wife team John T. Ward and Trish Russoniello, launched redbankgreen.com, the town's first digital-only newspaper, creating an online "town square for an unsquare town."

"We are deeply influenced by the model of the *Red Bank Register* of a century ago," said Ward, a 30-year veteran of the New Jersey news beat. "Our hope is to capture as much of the vitality of this region as we can while continuing the tradition of serious, community journalism." (Courtesy Red Bank Green.)

INDEX